# Digital Video
## POCKET GUIDE

**Also available from O'Reilly:**
*The Digital Photography Pocket Guide*

# Digital Video

POCKET GUIDE

**Derrick Story**

## O'REILLY®

Beijing • Cambridge • Farnham • Köln • Paris • Sebastopol • Taipei • Tokyo

# Digital Video Pocket Guide

by Derrick Story

Published by O'Reilly & Associates, Inc., 1005 Gravenstein Highway North, Sebastopol, CA 95472.

O'Reilly & Associates books may be purchased for educational, business, or sales promotional use. Online editions are also available for most titles (*safari.oreilly.com*). For more information, contact our corporate/institutional sales department: 800-998-9938 or *corporate@oreilly.com*.

| | |
|---|---|
| **Editor:** | Robert Eckstein |
| **Production Editor:** | Jane Ellin |
| **Cover Designer:** | Edie Freedman |
| **Interior Designer:** | David Futato |
| **Photographer:** | Derrick Story |

**Print History:**

| | |
|---|---|
| July 2003: | First edition. |

0-596-00523-7
[DS]

*This book is dedicated to Dana Winslow Atchley III,
who pioneered the art of digital storytelling. Dana was
a visual artist who knew how to "hold his shots,"
then arrange them into powerful videos that touched
the hearts and minds of viewers around the world.*

*He was a campfire raconteur with a minicam,
a historian with keyboard and mouse,
and a teacher who never stopped learning.
Dana Atchley died on December 13, 2000 following
complications from a bone-marrow transplant.*

# Contents

# Preface
## The Technology Has Changed, Not the Art

A few years ago, while I was participating in a digital story-telling workshop conducted by the late Dana Atchley, he shared an anecdote about how much technology has changed his world. Dana had been exploring the art of storytelling for years and had discovered video as a powerful medium for his work. At the peak of his career, Dana had several well-known clients, including Coca-Cola. He used short clips of video to tell personal stories about Coke to help strengthen brand loyalty for the product.

While he talked to us in this particular workshop, I noticed that he held a MiniDV camcorder in one hand. MiniDV was his current tool of choice. Of course, 15 years earlier, when he was struggling to establish himself in the ranks of professional video-makers, MiniDV wasn't available.

The anecdote that Dana told us was about his decision during those prior years to purchase a high-end video camera that was capable of producing broadcast-quality footage, allowing him to shoot professionally. He knew that to succeed in the highly competitive business of advertising and reporting, he needed the same tools that television pros were using. So he borrowed $60,000 U.S. and bought his camcorder. For that amount of money 15 years ago, he could have purchased a home in suburban America.

Dana explained that he had to maintain a variety of odd jobs to meet the obligations of his loan, and these siphoned energy away from the true purpose of his life: to create digital stories. At this point, Dana paused for a few seconds, smiled, and looked down at the MiniDV camcorder in his hand. Then he said, "Not long ago I sold that $60,000 camcorder on eBay for a few hundred dollars."

Today, you can drive to your local electronics store and—for less than $1,000 U.S.—purchase a MiniDV camcorder capable of producing professional-quality video. For another $1,000, you can buy a computer workstation to edit the footage and burn the DVDs. Advances in technology have broken down the cost barriers to quality video production.

The price of admission may have changed, but the approach to creating great-looking video remains virtually the same. Good camera technique, attention to lighting, and clean audio recording are just as important today, with modern camcorders, as they were in the early days of video.

In one of Dana's stories, entitled *Turn*, he opens with this statement: "My grandfather took home movies with an old Kodak 16mm movie camera. They didn't have zoom lenses in those days, *and he knew how to hold his shots*." Even with today's camcorders that include image stabilization, you still have to know how to hold your shot. You also have to know how to light it, record the audio, and edit the footage. Only the science has changed, not the art. In this book, you'll learn both.

Chapter 1, *What Is It?*, introduces you to your camcorder's components and features. Why does the camcorder include controls for exposure compensation, manual focus, and progressive scan? Your owner's manual will show you where these things are, but it doesn't include much information on *how to use them*.

By the way, I hope you haven't discarded your owner's manual—at least not yet—because it will help you identify where on your particular camcorder the functions discussed in Chapter 1 are located. Before you go any further in this book, dig your manual out of the sock drawer and have it handy for reference.

In Chapter 2, *How Does It Work?*, I'll walk you through the entire movie-making process, from start to finish. This will help you produce video that you can proudly show to others. There are many subtle techniques to learn, and when added up, they make a big difference between a successful project and an exercise in frustration.

For example, do you "black the tape" or prefer to "bump it"? Do you like to use paper for your log sheets, or would you rather use a computer? And when you edit, do you "capture on the fly," or are you more of a "batch processing" kind of person? Chapter 2 will help you work through these and many other issues so you can produce top-quality productions with ease and skill.

Then we get to one of my favorite segments of this book: Chapter 3, *How Do I... Tips, Tricks, and Techniques*. Here's where I get to share many of the secrets I've learned watching professionals working on commercial sets. How do you light a scene, shoot action video, and prevent wind from ruining your audio? There's lots of great stuff here that you can apply right now to your filmmaking.

Then, as a bonus, I've built an Appendix consisting of dense, informative tables that you can use for quick reference. Everything from lux ratings, to understanding color temperature, to identifying the correct type of cable connector is included and clearly presented in this section. You may read this introduction only once, but you'll refer to those tables time and time again.

We're lucky, you and me. For a modest investment, we can afford professional-quality tools capable of producing feature-length motion pictures. We don't have to choose between buying a camcorder or purchasing a house. All we have to do is learn how to use the tools we have, and let our creativity and vision take over.

—*Derrick Story*
*May 2003*

# 1

# What Is It?

Today's digital video cameras are evolved creatures whose ancestors first lumbered across the earth as bulky analog VHS camcorders straining the shoulders of soccer moms and proud fathers everywhere. As each subsequent format emerged— VHS-C, 8mm, Hi-8, MiniDV—camcorders shrank in size and refined their features.

The camera you have now, or the one you're considering buying, is atop an evolutionary pyramid that combines convenience, control, and quality into a single compact package. Not only have camcorders become smaller, their picture and sound quality are astounding by any standard.

The old VHS camcorder that you stashed in the closet or sold long ago on eBay was big, bulky, and capable of producing video at about 240 lines of horizontal resolution.

MiniDV camcorders, besides being much more compact, are capable of capturing video at 500 lines of resolution with CD-quality audio. Because it's digital, you can duplicate your recordings with no quality loss, or you can easily transfer footage to a computer for editing, then copy it back to another MiniDV tape. All of this quality is crammed into a camcorder that can fit into the palm of your hand, as shown in Figure 1-1.

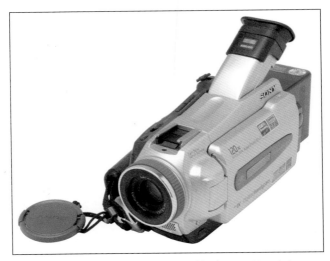

Figure 1-1. The Sony TRV18 is an entry-level model that features a 10x optical zoom and 120x digital zoom and rests comfortably in the palm of your hand.

But how do you take advantage of this power? Too often, people spend hundreds or even thousands of dollars for a brand-new MiniDV camera and use it the same way they did their old VHS friend: charge the battery, load the tape, push the button, and record.

You can follow that procedure with your new MiniDV camcorder and probably get much better results than ever before, but you can also capture truly great footage with just a little knowledge and practice. The quality of MiniDV is so good that it's already being incorporated into television broadcast systems and used by artists for feature-length motion pictures. One well-known example is the movie *Full Frontal* with Julia Roberts and Brad Pitt: the director, Steven Soderbergh, used a Canon XL1 MiniDV camcorder to shoot major portions of the project.

The first steps towards getting the most out of your camera are to become familiar with your camera's components, like those shown in Figure 1-2, and then to understand what they do. This chapter explains important features inside and outside your digital camcorder, enabling you to master its controls.

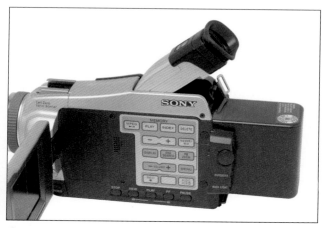

**Figure 1-2.** Even an entry-level DV camcorder such as the TRV18 is packed with features that most consumers never take advantage of.

You would never dream of setting off on a long road trip without understanding the basic controls of your car. Now you're going to have that same confidence in your DV camcorder.

This chapter first discusses the components on the outside of the camcorder. Keep the owner's manual handy to help you locate each function on your particular camera (see Figure 1-3). This chapter will tell you what those functions mean and how best to use them. Once you're familiar with the physical buttons and dials, you'll learn about some of the important parts inside, too, such as the image sensor and the audio recording system.

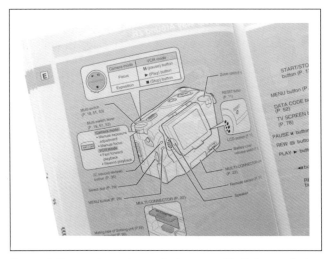

**Figure 1-3.** Your owner's manual may not be the most user-friendly document, but it can help you identify specific functions on your camcorder that you'll need to know as you work with the techniques in this guide.

If you have an upcoming project that requires new equipment, or if you're just getting started with digital movie-making, this chapter can also help you pick the right camcorder. You might not need a camera that includes a zebra pattern for reading "hot" exposures, but you really should get a camera with an optical image stabilizer for handheld shooting without picture compromise.

Each component is rated at one of three levels: basic, intermediate, or advanced. Make a list of the features that best suit your needs for an upcoming project or level of filming experience, then use that list to shop for the correct camcorder. Here's a brief explanation of how each feature is rated in this chapter:

*Basic features* ❸. These features should be on any digital camcorder you consider. Avoid a camera that doesn't

include all of these components; odds are you'll be disappointed with its performance.

*Intermediate features* ❶. In addition to the basics, these features are useful if you have previous movie-making experience or plan to advance your skill level.

*Advanced features* ❹. These features are for experienced filmmakers who are looking for a versatile camera that is capable of producing quality footage in a variety of shooting conditions.

If you're most interested in a dependable consumer-level camcorder that costs $600 or less, make sure the models you're considering include all the basic features in this section. Mid-level cameras usually run between $600 and $1,200 and should include most of the intermediate components; more advanced consumer models that run between $1,500 and $3,000 should have just about every item listed in this section.

Once you buy your camcorder, spend some time with the owner's manual to become familiar with the camera's unique design and how to access its controls (and make sure all the parts are in the box!). After that, keep this guide in your camera bag—not only does it provide a quick reference for the major components, but it will also help you understand how to use those features to record better footage.

# Outside of the Camcorder

Camcorder bodies are a mosaic of buttons and dials. At first you may think that most of them are superfluous and don't pertain to what you're doing. If you take a little time to learn about all the features, however, you'll probably incorporate them into your shooting, and soon capturing good video becomes easier than you ever imagined.

*Accessory shoe* ❸❶. The accessory shoe is a small bracket that typically sits atop the zoom lens. There are two types:

hot and cold. Cold accessory shoes ❸, like the one shown
in Figure 1-4, are more common on entry-level cameras
and serve only to hold video lights and other helpful
items, but no power is transferred from the camcorder to
the accessory via the shoe, hence the term cold. Hot shoes
❶, on the other hand, have contact points that enable
dedicated accessories to communicate with the cam-
corder. Power may also be transferred through one of
these contacts.

Figure 1-4. Most consumer camcorders have a "cold" accessory shoe such as the one
shown here. They have no electronic contacts to the camera's internal workings, but are
handy for mounting microphones and video lights.

The two most common accessories for hot shoes are
video lights and microphones. Some dedicated video
lights will even go on and off automatically as the camera
measures exposure during recording. Powered micro-
phones are also useful because they're usually directional

(pointed toward the subject) and less likely to record distracting camera noises. Keep in mind, though, that the quality of these "mounted" mics still isn't as good as most "free-standing" external microphones.

A creative use of the accessory shoe is to attach a flexible arm with a clip on the end for attaching lens shades and vignettes, as shown in Figure 1-5. This flexible arm becomes your "third hand" and makes location shooting much easier.

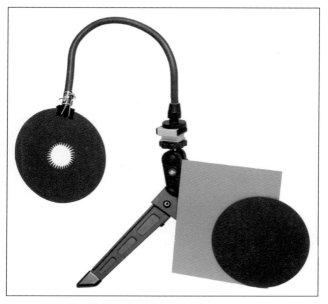

**Figure 1-5.** An affordable but highly useful accessory for your camcorder is the Flare Buster (*http://www.multiclip.com/*) that serves as a flexible lens shade, filter holder, and grip for props. Also shown is the UltraPod II (the Flare Buster is mounted on it instead of a camcorder as it normally would be). The UltraPod II is a sturdy, portable support that folds up and fits in your back pocket.

*Analog line-in terminal* ❶. This feature allows digitizing of existing video content from another source. You can connect your VCR, for example, to the analog line-in terminal of your DV camcorder and transfer those old, deteriorating VHS tapes to the new digitized format. Note that the life expectancy of traditional VHS tape is only 10 years. Your new DV camcorder with analog line-in can be a valuable tool to help you salvage and preserve cherished memories captured on VHS.

*Audio/Video terminal* ❸. A great way to preview your just-recorded video is to connect your camcorder directly to a television for playback. Plug one end of the video cable that came with your camera into the audio/video terminal on your camcorder. The other end of the cable has three RCA-style jacks that are colored yellow, red, and white. Match the colors to the input jacks on your TV. The yellow jack is for the video feed, and the red and white jacks are for the stereo sound connection. You can use this same setup to connect your camcorder to a VCR. However, you typically won't use the A/V terminal to connect your DV camcorder to a computer. (See the information in this section on the DV terminal for more information.) This connector is sometimes used for external monitors during recording, such as when using a steadicam.

*Display and Data Code button(s)* ❸. Some cameras combine these two functions into one button (Display/Data Code), as shown in Figure 1-6, while others provide a button for each. The Display button usually reveals the battery status, number of minutes left on the tape, recording speed, and timecode. See the section Manage Timecode in Chapter 2 for more information.

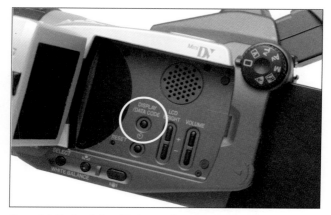

Figure 1-6. The Data Code and Display controls are sometimes combined into one button, as shown here, or they may be separate buttons. They are typically located close to the LCD monitor.

The Data Code button typically shows the date and time, but often it can make visible other camera settings used for the footage, including shutter speed and aperture. On a related note, make sure your camcorder's internal clock is always set properly so you have accurate data code on your recorded tape.

*DV terminal* ❸. Use the DV terminal, shown in Figure 1-7, to connect your digital camcorder to a computer for viewing, transferring, and editing both video and sound. Technically, this is an IEEE 1394 connection, which refers to the jack and protocol, but it is also called the DV, FireWire, or i.Link terminal. Regardless of how it's labeled on your camera, speed is what separates communication via this terminal from other connections, such as a USB port. IEEE 1394's "isochronous" data transmission is so fast that you can transfer video, plus stereo sound, at 29.97 frames per second, *in real time*.

A special cable is used for this high-speed transfer between camcorder and computer. The cable has a larger

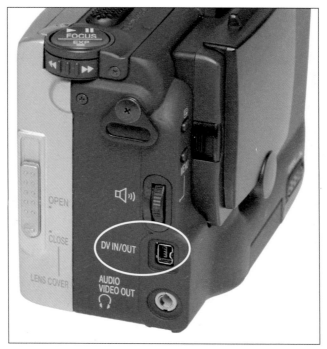

Figure 1-7. The DV terminal, shown here with the "DV IN/OUT" label, connects your camcorder directly to the computer for high-speed audio and video transfer using the IEEE 1394 communications protocol.

six-pin connector on one end that attaches to the computer, and a smaller four-pin connector on the other end for your digital camcorder. The small end is somewhat fragile, so connect it to your camera with care. Once the connection is made and everything is turned on, your computer should recognize your camcorder, enabling viewing and transfer of data.

*Exposure compensation control* ❸. Your camcorder is capable of automatically adjusting exposure to provide properly exposed footage ... most of the time. However, there

are occasions when the camera's automatic system is fooled, such as with strong backlighting, and you need to manually adjust the exposure to better render the image.

Locate the exposure compensation control (see Figure 1-8) on your camera for these situations. By moving the exposure compensation indicator to the minus (–) end of the scale, you're subtracting exposure, rendering the image darker. If you move the indicator to the plus (+) end of the scale, you are adding exposure and making the image lighter.

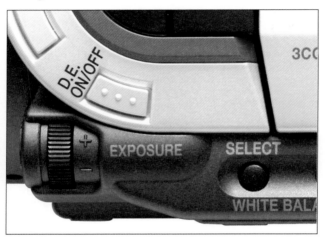

Figure 1-8. Sometimes you have to search for the exposure control, but it's good to know where it is and how to use it, especially in backlit situations.

The most challenging exposure situation is usually backlighting, such as a bright sky behind the subject. Without compensation, the subject usually turns out too dark. In this situation, set the exposure compensation to +1 or +1.5, and your subject should look much better.

Again, the default setting for camcorders is just fine for normal shooting situations, such as outdoors on a sunny

> ### PRO TIP
>
> Typically, when digital camcorders say exposure, what they
> really mean is aperture control. That's the method
> camcorders use to darken and lighten the image via the
> exposure compensation control. Unlike with still cameras,
> shutter speed isn't normally part of the exposure equation
> on camcorders because slowing down or speeding up the
> shutter has other ramifications. For more information, see
> the discussions on aperture and shutter speed, both in the
> Inside the Camcorder section, later in this chapter.

day. But when you do encounter difficult lighting, such as
backlit scenes, use the exposure adjustment to improve
your image. For more information about shooting backlit
scenes, see Tip 4: How to overcome backlighting, on page
75.

*Fader trigger* ❶. See the Fade special effect in the Inside the
Camcorder section on page 31.

*Fast forward button* ❸. There are two types of fast-forward:
headless shuttling and head-engaged shuttling. Headless
shuttling occurs when you hit the stop button first—
which pulls the heads away from the tape—then hit the
fast forward control. The tape moves forward faster, but
you can't see images on the screen. When the heads are
engaged, which occurs when you press fast forward while
the tape is in play mode, the tape moves slower, but you
can see the images on the LCD. To extend the life of your
camcorder, headless shuttling (forward or reverse) is rec-
ommended whenever possible. It reduces wear and tear
on the heads and the drive mechanism.

*Filter ring* ❶. Some camcorders have added screw-in threads
around the lens. Often this is referred to as the filter ring,
and it enables you to attach filters to cover the outside of
the lens. Some filters are designed primarily to protect the
front of the lens (sky and UV filters), others enhance or

adjust the color saturation (polarizer), and some special effects filters actually alter the image, such as softening it to create a dream-like image. The most popular of this type of filter is the Tiffen Pro-Mist (see Figure 1-9). If you plan to expand your movie-making skills, make sure your camcorder has a filter ring so you can add filters as you are ready to experiment with them.

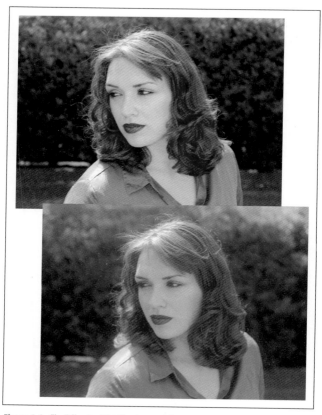

**Figure 1-9.** The Tiffen Pro-Mist filter is one of the easiest special effects to add to your bag of tricks. The top image is the subject with no filtration, and the bottom is with the Pro-Mist filter.

The filter ring can also be used to attach accessory lenses. The first lens you'll want to consider is a wide-angle lens that expands the angle of coverage. The zoom lens on your digital camcorder already has a powerful telephoto, but you'll notice that on the wide end, the angle of view is narrower than what you're accustomed to in still photography. A 0.7x wide-angle converter will prove helpful when working in tight spaces or shooting expansive scenes. For more information, see the Lens entry on page 15.

*Flash* ❶. Many camcorders allow you to take high-quality still images and can be equipped with external flash units. These flashes operate just like the ones on your still digital camera—in low light they provide a short, intense burst of light to help you properly expose the picture. If you plan to use your camcorder for still pictures as well as digital footage, either a built-in flash or an accessory shoe for a dedicated external flash should be on your required feature list.

*Grip* ❸. All camera engineers have thought about how you're going to hold the unit while filming, but some ultra-compact camcorder designs, such as the Sony DCR-IP55, require a fold-down grip for stability. Regardless of the type of grip your camcorder has, it's generally best to use two hands while filming—one hand on the grip (or inside the grip belt) and the other helping to steady the camera.

*Headless shuttling* ❸. See Fast forward button or Rewind button.

*Headphone jack* ❸. Plugging headphones into this jack is useful for both monitoring audio during recording and reviewing it afterward. Stereo mini-jacks are standard on most digital camcorders.

*IEEE 1394 terminal* ❸. See DV terminal.

*i.LINK terminal* ❸. See DV terminal.

*LANC terminal* ❶❹. The Local ApplicatioN Control bus system was designed by Sony. It is a bi-directional wired command protocol designed for communication between video products, mainly editing stations. The LANC port is often labeled LANC or Remote. There are two types of LANC connections: a 5-pin connector is used on decks, while camcorders use a stereo mini-plug to save space and weight.

*LCD screen* ❽. Generally speaking, Liquid Crystal Display screens come in two sizes: 2-inch and 2.5-inch (diagonally measured). When viewing video, during both recording and playback, there's quite a difference between the two dimensions, and it's something you want to view first-hand before making a purchase decision. Swiveling LCD screens enable more creativity in shooting angles, and most can even be turned completely around for self-portraiture. Keep in mind, though, that you'll use battery power much more quickly if the screen is always on. If you're in a situation where you need to conserve energy, turn off the screen and use the viewfinder instead.

*Lens* ❽. DV camcorders have amazing lenses compared to their still-picture counterparts, at least on the telephoto end. It's not unusual for digital camcorders to have optical zoom lenses with 10x or 20x magnification, while still-picture cameras usually top out at 3x.

The reach of the telephoto end of the zooming range is certainly spectacular, but when you start paying attention to the wide-angle end of the zoom, you'll notice that optical performance is far less impressive. Quite honestly, most camcorder lenses have a relatively narrow field of view. And when you take your camcorder into confined spaces for shooting, you'll often find that you can't get everything you want into the frame.

Consequently, if you're considering auxiliary lenses at all, think wide. A 0.7x or 0.8x wide-angle lens can help you

capture a scene with the breadth you've become accustomed to with film cameras.

Also be aware of the difference between optical zoom and digital zoom numbers (see Figure 1-10). Camera manufacturers too often put only the more impressive digital zoom rating on the lens barrel. Don't be misled: you should always base your buying decision on the *optical* zoom rating, not the *digital* zoom.

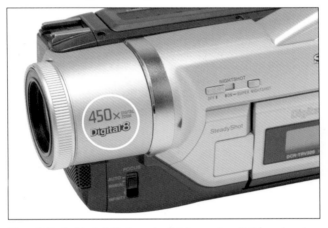

Figure 1-10. Don't be fooled by impressive digital zoom ratings. Digital zooming magnifies the images electronically, not optically. Hence, the image quality is softer and less detailed.

Sometimes, you'll see both sets of numbers listed on the camcorder, like this:

20x/400x Zoom Lens

In this case, the first number is the optical zoom rating, based on the actual glass elements that comprise the lens assembly. The second number is the digital zoom rating, which magnifies the image electronically, not optically. When the digital zoom is enabled, the camera literally makes the pixels bigger to achieve the listed magnification.

The end result of using the digital zoom is a softer, lower-quality image. Invest your money in the lens with the optical rating you need, and for the most part, ignore the digital zoom.

One last number you might encounter when reviewing the specs for a lens is its aperture rating, expressed as f-stops. You'll typically see a listing such as f-1.8–2.8. The first number (1.8) is the aperture rating at the wide end of the zooming range. The smaller the number, the more light the lens can let in. This is important in low-light shooting. The second number is the aperture rating at the telephoto end of the zoom lens. It will generally be a higher number because as you increase magnification, there's some light loss. The main thing you have to remember is that smaller f-stop numbers mean easier shooting in low light.

*Lens hood* ❶. To appreciate the function of a lens hood, that cup-shaped black plastic tube that extends from the front of your zoom, you need to be familiar with the demon of outdoor photography: lens flare. Few things can deteriorate image quality faster than sunlight shining directly onto the front of your lens. A lens hood helps "shade" your optics, thereby eliminating flare.

If your camcorder does not accept a lens hood, this pocket guide makes an excellent temporary lens shade (you'll always have it with you in your camera bag, right?). Simply hold the book up over the lens to provide a temporary shade to eliminate flare. If your camera has an accessory shoe, try using a flexible arm with a shade attached at the end to protect against flare. See Figure 1-5 on page 7 for an example.

One last note about the lens hood: it also protects the front of your lens from accidental bumps and bruises. If your camcorder accepts a lens hood, you might want to leave it on while working, inside or out, just for protection.

*Manual focus control* **B**.  Nearly all digital camcorders have manual focus, but some are easier to use than others. This is an important control, so make sure it's easily accessible on your next purchase.

Autofocus is wonderful, but it's actually more reliable on digital still cameras than DV camcorders. Why? With still cameras, the autofocus system "locks in" on a subject, and you take the picture. But with camcorders, subjects are moving, distractions enter and leave the frame, and you're moving the camera around. Autofocus systems often detect these various distractions and alter the focus for a few frames to accommodate the new element.

This is especially true when the distracting element enters the frame closer to the camera than the primary subject. You've seen it in your own movies: you're recording your daughter talking and suddenly the camera lunges out of focus for a few seconds because your son enters the frame at a closer depth. This is very distracting, and it often ruins the snippet of footage.

By manually focusing on your daughter during the shot, her image stays sharp throughout the scene regardless of any distractions entering and exiting the frame. The easier

---

### PRO TIP

The ultimate in image quality for interviews and other "static" scenes involves using manual focus while the camcorder is perched on a tripod with a fluid head. Tripods have two major components: the legs and the head (sorry, no body!). In video work, a fluid head is helpful for smooth camera movement while recording. When shopping for a fluid head, look for controls that help you pan and tilt smoothly, plus those to adjust drag and counterbalance. Good fluid heads can cost many times more than the tripod legs, so weigh features and costs when researching.

---

it is to use manual focus on your camera, the more often you'll enable it.

Some camcorder engineers have figured out this "the easier it is, the more it will be used" concept and have made improvements to the manual focus control. One approach that's particularly smart uses a "focus button," which auto-focuses on the current subject while in manual focus mode, then leaves the focus alone no matter how much you move the camcorder around. You might want to add this feature to your list of desirable functions.

*Microphone (built-in)* ❷. The good news: your DV camcorder records 16-bit PCM stereo digital audio. The bad news: too many people depend on their camera's built-in microphone, even though it produces audio far inferior to the capabilities of the unit's electronics. This situation is particularly bad on compact camcorders where the microphone port is close the noisy drive mechanism.

The best way to approach the built-in microphone is to understand that it's an option for some situations, but not *every* situation. It is good for recording ambient sound: waterfalls, the hum of traffic, even "white noise" in a room, but it is not as strong for interviews and dialog. For these situations, use an external microphone that moves the audio input device away from the camcorder itself.

Some advanced camcorders, such as the Sony DCR-VX2000, Panasonic AG-DVC15, and the Canon GL2, position the microphone atop the camcorder body on the carry handle, which captures much better audio than on-camera microphones (see Figure 1-11). A convenient option for less expensive camcorders that have accessory shoes, such as the Canon ZR70, is to attach an external microphone in the shoe. These accessory mics provide higher quality audio than the built-in types.

For a handy comparison of microphone types, see Table A-9 in the Appendix.

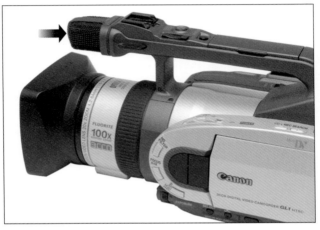

**Figure 1-11.** Some more advanced camcorders position the on-camera microphone on the handle, away from the body. This helps improve sound quality, but it's still not as effective as an external microphone.

---

**PRO TIP**

Say you have many people interacting in dialog, but you don't want to use an on-camera microphone. How do you solve this problem? If you have an assistant, you can use an inexpensive boom holding a cardioid (or "shotgun") mic over the heads of the talent but out of view of the camcorder. Your assistant can move the boom to follow the action, ensuring high quality sound. If you don't have an extra set of hands, you can put the boom on a microphone stand. Stands are expensive, though, and a stand won't follow your subjects as they move. Better to get a good assistant and buy lunch for everyone.

---

*Microphone jack* ❸.  Regardless of the type of built-in micro-phone you have, some situations dictate that you use an external mic. MiniDV camcorders use the 1/4" mini input jack for external mics. If your microphone has the full-size plug, you can get an adaptor at any electronics store for just a couple of bucks. You may want to look at wire-less mics, too. Wireless kits include a small transmitter that the mic plugs into and a receiver that has an output mini-plug for your camcorder's microphone jack. Beginner's rigs, such as the Azden WMS-Pro kit, can be purchased for $250 U.S.

*Pause button* ❸.  This button "pauses" the tape during play-back or recording. Most camcorders automatically switch to "stop" if you leave them in pause mode for more than 5 minutes to prevent wear on the tape and the camera heads.

*Play button* ❸.  Initiates playback when in viewing mode.

*Record button* ❸.  Initiates recording when in capture mode.

*Remote control* ❸.  Also referred to as the wireless controller, and shown in Figure 1-12, this device looks like a smaller version of your VCR remote control, using an infrared transmitter to communicate with the camcorder. Some remotes have more range than others, and if you plan on using this device regularly, be sure to check its specs for effective distance.

*Remote sensor* ❸.  It's worth the effort to locate the infrared receiver on a potential purchase to make sure it's placed on the front of the camera near the lens. Infrared requires that the transmitter and receiver are within line of sight of each other. If you plan to use the remote control for self-recording, or for shooting interviews when you are both the cameraman and the moderator, front placement of the sensor is important.

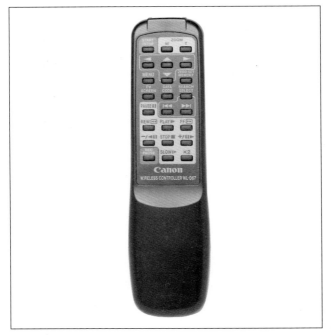

**Figure 1-12.** Wireless controllers enable you to operate the camcorder (usually on a tripod) from a distance. You can zoom in and out, record, pause, fast forward, and rewind. Typically remote controls are pressed into service when the cameraman wants to get into the act. Group portraits and interviews are common situations for these devices.

*Rewind button* ❸. Used to reverse the tape after playback or recording. There are two types of rewind: headless shuttling and head-engaged shuttling. Headless shuttling occurs when you hit the stop button first—which pulls the heads away from the tape—then hit the rewind control. The tape moves backwards faster, but you can't see images on the screen. When the heads are engaged, which occurs when you press rewind while the tape is in play mode, the tape moves slower, but you can see the images on the LCD. To extend the life of your camcorder, headless shuttling (forward or reverse) is recommended

whenever possible. It reduces wear and tear on the heads and the drive mechanism.

*Self-timer button* ❶. Self-timers are typically included on camcorders that include still photography functionality. Once you activate the self-timer, it waits for a predetermined amount of time (often 10 seconds) before activating the shutter.

*S-Video terminal* ❸. You can connect your DV camcorder to other analog recording devices, such as VHS decks and Hi-8 camcorders, via an S-Video cable (see Figure 1-13), which provides a higher-quality analog signal than RCA plugs and connectors. If you use S-Video for dubbing to a VHS deck, for example, you'll still need an audio connection too.

**Figure 1-13.** Of the three types of corded connectors shown here—(from left to right) RCA, S-Video, and stereo mini-plug—S-Video connectors are the most fragile. S-Video provides a higher-quality signal than RCA connectors, however.

*Tally lamp* ❹. Located on the front of the camera, the tally lamp is usually a red LED that illuminates when the camera is recording to let crew members and talent know that filming has begun. The term evolved from 19th-century mining, where tally lamps (short for tallow) were open-flame lanterns attached to the fronts of miners' caps so

they could see while working. Today's electronic versions are much safer.

*Tripod socket* ❽. This threaded socket on the bottom of the camera allows you to secure your camcorder on a tripod, monopod, or steadicam to keep it stable during recording.

*USB terminal* ❶. Some DV camcorders enable you to save still images to Flash memory cards and other media. Often these camcorders also include a USB terminal to enable you to transfer the still-picture data to your computer. USB (1.0) is not used for digital video data because the transfer rate is too slow. For more on video transfer see DV terminal earlier in this section.

*Video light* ❶. Viewed by many serious enthusiasts as the occasional necessary evil, the video light is a portable light source that often attaches the camcorder's accessory shoe and helps illuminate scenes indoors and in other low-light settings. Some camcorders even have built-in video lights.

The reason many videographers use on-camera video lights reluctantly and only as a last resort is because of their harsh, contrasty rendering of subjects, due to the small, laser-like light source. *Unflattering* is the term that comes to mind when viewing footage shot this way.

If you can, use natural light as much as possible. If you must use artificial light, review Tip 8: How to master three-point lighting on page 83. This technique isn't appropriate for all situations, but it does render much more flattering video when it can be used.

*Viewfinder* ❽. The color viewfinder with its rubber eyecup enables easy composition in bright conditions, when it would otherwise be difficult to use the LCD screen. Another advantage to using the viewfinder is that it requires less power than the LCD screen, extending battery life.

*Wireless controller* ❸. See Remote control, earlier in this section.

*Zoom control* ❸. The zoom control allows you to adjust your camera's focal length from wide angle to telephoto. The key word for accessing this function is *restraint*. Generally speaking, compose your shot *before* you start filming and resist zooming in and out while the camcorder is running. On occasion, you may want to inch closer to the subject with the zoom control while filming, but do so sparingly. Some camcorders have variable zoom control. When you press lightly on the button, the zooming action is slow and smooth. As your press harder, the zooming accelerates. This feature gives you much better control while filming.

---

**PRO TIP**

The *hold-zoom-hold* technique is used by filmmakers on those few occasions when zooming is appropriate. Begin rolling and hold the shot for five seconds, then slowly zoom for five seconds, then hold for another five seconds.

---

# Inside the Camcorder

Now it's time to see what all of those buttons on the outside of the camcorder are controlling on the inside. You probably don't care about every wire and electronic component, but not all camcorders are created equally, and it helps to understand their inner workings when choosing equipment for your various projects. Here's a look at a few of the key elements and functions.

*16:9 recording mode* ❶. If your video is designed to play on wide-screen televisions (often HDTV) or "theater format" (also known as letterbox), you may want to enable the 16:9 recording mode. By doing so, you will capture the

footage in the same perspective that it will be viewed. The caveat? Make sure your post-production software allows you to work in this wide perspective.

Figure 1-14 shows the difference between 16:9 and standard dimensions.

**Figure 1-14.** Comparison of 16:9 perspective (blue line) to standard 720 x 480 dimensions (green line).

*Aperture* ⓑ. When you hear the word "aperture," you're probably thinking more about still photography than video. That's because video cameras usually apply the label *exposure* to the aperture control. But regardless of the label, controlling the light-emitting diaphragm at the base of your camcorder's zoom lens is just as important in video capture as in still photography.

Aperture (or exposure) determines the amount of light that can pass through the lens to the camera sensor. Wide apertures, such as f-1.6 or f-2.0, allow a lot of light to reach

the image sensor and therefore are better in low light conditions. More narrow apertures, such as f-16 or f-22, are useful in bright lighting conditions, such as outdoors on a sunny day. Table 1-1 lists characteristics of different f-stops.

Table 1-1. Aperture diameters and depth of field.

| f-stop | Diameter of aperture | Depth of field | Background looks... |
|---|---|---|---|
| f-2 | Very large diameter | Very shallow | Very soft |
| f-2.8 | Large diameter | Shallow | Soft |
| f-4 | Medium diameter | Moderate | A little out of focus |
| f-5.6 | Medium diameter | Moderate | A little out of focus |
| f-8 | Small diameter | Moderately deep | Mostly in focus |
| f-11 | Small diameter | Deep | Sharp |
| f-16 | Very small diameter | Very deep | Very sharp |

In Program or Auto mode, your camcorder automatically adjusts the exposure according to the lighting conditions. Generally speaking, auto settings provide terrific footage. But on occasion, such as when your primary subject is backlit (the light coming from behind the subject is stronger than the light falling on the front of the subject), your camera's auto-exposure system will adjust for the brightest element in the scene (the backlighting, such as the sky) and not the subject you're filming. In those instances, you may want to manually increase the exposure to render the subject properly. Typically the best way to do this is to stay in program mode but use the exposure compensation control.

Even if you don't plan to use manual overrides much, it's wise to become familiar with the controls so that you can capture a properly exposed shot if a situation presents itself in the field.

*Audio recording system* ❸. Also see Microphone (built-in) and Microphone jack in the earlier section Outside of the Camcorder. Many DV camcorders provide you with two

options for audio recording: 16-bit (48 kHz, 2 channels) or 12-bit (32 kHz, 4 channels). The 16-bit option is often referred to as CD-quality stereo, even though it's slightly better than that. The 12-bit mode provides less quality but does leave 2 channels open (one stereo sound track) for additional audio recording.

The original thinking behind providing a 12-bit mode on DV camcorders was to leave a stereo track open for additions to the dialog track. However, modern nonlinear editors such as Final Cut Pro/Express, Premiere, and iMovie allow you to add 16-bit tracks in post-production. Hence, there's no need to compromise on original audio capture just so you can add music and effects later.

You're probably best served by capturing your original dialog track in 16-bit CD-quality stereo, then adding what you need later with your nonlinear video editor.

---

**PRO TIP**

In the film industry, sound is divided into three categories: music, dialog, and effects. Most of what you record during live filming would be considered part of the dialog track. You could add music and effects (heavy footsteps, creaky door opening, etc.) in post-production if the project needs those enhancements. But during original filming, try to capture the best dialog possible; it's hard to reproduce dialog in post-production without it sounding like studio voiceover.

---

*Battery* ❸. Aside from the videotape itself, the battery (see Figure 1-15) is the most likely component to put a quick end to shooting a great scene. No power, no recording. Lithium ion (LiIon) is the most popular battery technology, featuring fast charging time, relatively long life, and no "battery memory." In other words, you can recharge the battery at any time with no fear of reducing its capacity.

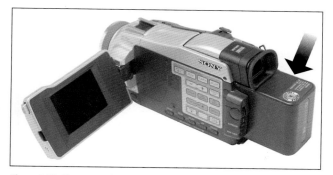

Figure 1-15. Many camcorders, such as this Sony TRV18, have accessory "extended life" batteries you can use to extend your shooting time. These batteries do add some bulk and weight, but the tradeoff is usually worth it for special events.

When using your DV camcorder, however, beware of low-battery warning systems. They are notoriously inaccurate. You usually have only a few minutes of shooting time left once the warning activates. (Sony's InfoLithium batteries are a notable exception: they communicate better with the camcorder, providing more accurate level readings.) The best policy is to always have a spare, charged battery on hand so your taping session isn't interrupted by a sudden power outage.

Also, take the number of minutes of recording time advertised by manufacturers with a big grain of salt. Those minutes are even less trustworthy than the "miles per gallon" rating that car makers list on the sticker. Camcorder battery life is calculated by continuous shooting time. In other words, if you turned the camera on and left it shooting until the battery ran out, that would approximate the advertised battery life. Most people shoot in short segments, stopping and starting the camera frequently, which uses the battery's power about twice as fast as the advertised capacity.

Finally, while it's true that lithium-ion batteries look like indestructible bricks, in reality, they're quite fragile. Be

careful not to drop them, and at all costs avoid getting them wet.

*Bluetooth* ❶. This wireless technology uses the 2.4-GHz band and enables devices to "talk" to each other, transferring data across the established network. This functionality is now being incorporated into some DV camcorders, most notably those by Sony. It can be used to transfer still images from the camcorder to the computer or to stream video wirelessly from the camcorder to the computer, then across the Internet to a receiving computer.

Sony has developed Bluetooth streaming to work with Microsoft's NetMeeting and Movie Maker applications, both of which run on the Windows platform. The advantage of using wireless technology such as Bluetooth is that you can place the camcorder anywhere within range of the computer and perform the transfer without fussing with wires of limited length. Since Bluetooth's effective range is up to 10 meters (30 feet), this provides great flexibility for video conferencing and other streaming applications.

One last thought: if your camcorder is Bluetooth-enabled, theoretically it can "talk" to any other Bluetooth device, such as your cell phone, PDA, or even printer. This could lead to even greater flexibility as this technology evolves.

*Data Code* ❽. See also Display and Data Code button(s) in Outside of the Camcorder. A special section of your DV tape is reserved for recording the data code, which includes date, time, shutter speed, and exposure. You have the option to display all or part of the data code during playback. Make sure your camcorder's internal clock is set correctly so this information is accurate.

*Exposure* ❽. See Aperture in Outside of the Camcorder.

*Fade special effect* ❸. There are two types of fade effects: fade in and fade out. Both types transition from video footage to black. Fade in begins with black and dissolves to video. Typically this effect is used at the beginning of a scene. Fade out dissolves from video footage to black and is most often used at the end of a scene.

Nearly every DV camcorder enables you to add this effect using the in-camera controls. In other words, you can turn on the fade-in function and start the tape rolling, and the camera will dissolve from black to the first few frames of the footage you're recording.

You may find this effect useful if you don't plan to edit your footage with a computer (ack!), but every nonlinear video editor allows you to add fades during post-production, which is the recommended time for adding this effect.

*Focusing system* ❸. More than likely, you have two types of focusing systems available on your digital camcorder: Through the Lens (TTL) auto and manual. TTL auto-focus is popular on both camcorders and still-photography cameras because of its accuracy and speed. It handles the focusing tasks for you and lets you concentrate on composition.

The problem with even the most advanced autofocus systems is that they can be fooled, or they choose an object to focus on that's not your intended subject. That's why it's important that your camcorder also includes an easy-to-use manual focus system.

Most people use manual focus when they want to "lock in" on a subject. The easiest way to do this is to autofocus on the subject first, then switch to manual so the focus doesn't move.

At the end of the scene, make sure you return the setting to autofocus. That way you won't accidentally shoot the next scene (which more than likely is at a different distance) at a less than perfect focus setting.

---

**PRO TIP**

If you want to create a shot where you slowly zoom in on a subject's face, try this technique used by pros. While the recording button is paused, zoom in on the subject's face, compose the shot, and manually focus until the image is sharp. Leaving the camcorder in manual focus mode, zoom out to the beginning part of the shot. Now start recording and slowly zoom in on the subject. When you get to the end of the zoom, the subject's face will be in focus and well-composed.

---

*Image sensor* ❸❶❹.  At the heart of every digital camcorder is the charged-couple device (CCD) image sensor that measures light and translates the information into electrical charges. A bright light hitting the sensor results in a higher charge; dimmer light creates a lower charge. These different light intensities and their corresponding charges are what create the video image when played back on a television screen or computer monitor.

Many consumer digital camcorders use a single CCD chip that's approximately 1/4-inch in size and supports around 500,000 total pixels, of which 350,000 or so are usually effective.

When comparing digital camcorder specifications, you will usually see both the total pixels and the effective pixels listed. Use effective pixels for comparison purposes because those are the pixels that are available for actually recording the image.

Advanced digital camcorders use three CCDs for capturing images. By dividing the work among three sensors,

whether by color (red, green, blue) or by different types of signals (luminance and chrominance), "3-chip" camcorders generally provide better video. But since the quality of DV is so high to begin with, you'd probably have to compare video from "single-chip" and "3-chip" camcorders side by side to see the difference in image quality. There is a much more noticeable difference in color depth, however, with 3-CCD camcorders showing superior color rendering.

Another important rating for image sensors is lux, a light measurement roughly equivalent to one candle at the distance of one yard. Most image sensors have two types of lux ratings: minimum and recommended.

The minimum lux rating determines how well the camcorder can retain color fidelity and image quality in low light. A minimum lux rating of 1 or less indicates good low-light performance. A minimum lux of 2 to 3 will show some loss in contrast and color. And a minimum rating of 4 lux or higher means the camera isn't really designed for shooting in low light.

The recommended rating that most camcorders prefer for optimum performance is 100 lux. See Table A-5 on page 99 for more information.

You may also have heard the terms "progressive scan" and "interlace" options. The progressive scan option captures a full-frame video image 30 times a second, producing high-quality video (and some new high-end camcorders, such as the Panasonic DVX100, can go with frame progressive at 24 instead of 30, which is very desirable when making film transfers). Camcorder electronics that enable this are good for capturing still pictures. There are variations on this noninterlaced approach to capturing video, and sometimes you'll see terms such as "Frame Movie Mode"—that's an option for the Canon GL2. This mode is better for transferring footage to computer.

Interlaced-type capture is more traditional and captures half a frame 60 times a second (sometimes referred to as a "field"), then combines (interlaces) the fields together during playback. With this approach there's a brief time lapse between fields that can result in flicker when the video is paused during playback. Interlace mode does offer a better transfer to film, however. (For more information about this type of recording, see Interlaced video later in this section.)

So what characteristics should you look for in an image sensor? That depends on whether you're shopping for a beginner, intermediate, or advanced camcorder. Table 1-2 will help you pick the right sensor for the filming you want to do.

**Table 1-2.  Image sensor characteristics for beginner, intermediate, and advanced DV camcorders.**

| Beginner | Intermediate | Advanced |
| --- | --- | --- |
| 1 CCD | 1 CCD | 3 CCD |
| 3 lux or less | 1 lux or less | 1 lux or less |
| Minimum illumination | Minimum illumination | Minimum illumination |
| Interlaced-type capture only | Noninterlaced option available | Noninterlaced option available |

*Image stabilization* ❷❶.  Not all image stabilization schemes are equal, and you should understand the options on your camcorder to ensure you're always recording the highest quality footage possible.

Digital and electronic stabilizers ❷ are the most common and work by magnifying the image slightly, then subtracting extra movements and recording only a subset of the picture. This approach can reduce image quality as much as one third. If your camcorder simply says "Image Stabilizer" on the box, chances are this is the type it's using.

Optical image stabilizers ❶ use a prism that moves opposite the shaking camera. This system does not adversely

affect image quality, but it is usually available only on more expensive cameras. Look for "Optical Image Stabilizer" in the documentation.

Keep in mind that any type of stabilizer is designed for handheld shooting only. If you've tripod-mounted your camcorder, remember to turn off image stabilization because it's not needed and can compromise image quality. Use electronic image stabilizers only when the situation requires it. Sometimes a slight reduction in image quality is worth trading for reduced shakiness. Overall, though, it's best to keep digital and electronic stabilizers turned off.

*Interlaced video* ❸. Video recorded using the NTSC, PAL, or SECAM standards is interlaced, which means each frame consists of two fields displayed using two passes. The roots of interlaced video lie in early television, which could only display video at 30 frames per second (fps), showing some flicker because of limited persistence of the phosphors dots. By interlacing the alternating even and odd horizontal lines, TVs could present the illusion of 60 fps, making your eyes believe they were seeing a steady image. As the even lines were fading, the odd ones would just be illuminating. But if you pause an interlaced image, you see its telltale flicker because the illusion of motion is disrupted.

Even if your digital camcorder captures video in an interlaced format, your can deinterlace it in post-production by converting the interlaced fields into complete frames. Typically, you do not need to do this unless you plan to freeze frames or slow down playback.

The alternative to interlaced video is noninterlaced video, which is usually referred to as progressive scan.

Table 1-3 lists characteristics for the three formats.

**Table 1-3: Interlaced video characteristics for NTSC, PAL, and SECAM formats.**

| Format | Fields | FPS | Scan lines |
|---|---|---|---|
| NTSC (National Television Standards Committee) | 60 | 30 | 525 |
| PAL (Phase Alternating Line) | 50 | 25 | 625 |
| SECAM (Sequential Couleur A Menorie) | 50 | 25 | 819 |

*Lux* ❽. See Image sensor earlier in this section for more information. Lux is a light measurement roughly equivalent to one candle at the distance of one yard. For digital camcorders, the minimum lux rating determines how well the camcorder can retain color fidelity and image quality in low light. A minimum lux rating of 1 or less indicates good low-light performance.

*Memory card* ❶. More and more digital camcorders are adding improved still-picture capability in addition to digital video capture. As a convenience, these dual-purpose camcorders often include a removable memory card in addition to digital video tape as a medium for recording imagery. Sony camcorders use Memory Stick media for digital stills and short MPEG movies. Canon and others seem to be leaning toward SD Memory Cards and MultiMediaCards as their removable memory of choice.

If you're considering such a dual-purpose camcorder, pay attention to the still-picture resolution (many are featuring 1.3 megapixels), type of memory card, and the ability to upload still images to your computer via USB or FireWire.

*MiniDV videotape* ❽. Even though it's only 6.35 mm wide (1/4 inch) and 65 meters long, a 60-minute MiniDV tape (see Figure 1-16) can store up to 13 GBs of data. DV tapes are available in different lengths: 30, 60, and 83 minutes of recording in standard mode. In long-play modes, minutes can be extended by about 50 percent, but this is not recommended because of possible quality degradation.

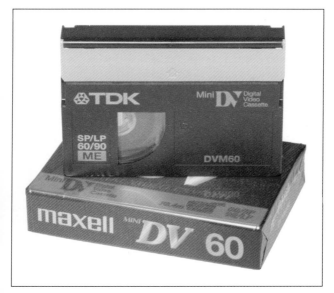

**Figure 1-16.** Even though they're small in size, MiniDV tapes can hold gigabytes of information. They are relatively fragile, so keep them protected in their cases when not in use.

Videotape produced by major manufacturers has ample quality for years of recording and playback. Generally speaking, you don't need to spend the extra money for special "high-quality" tapes unless you want an extra bit of insurance for once-in-a-lifetime occasions.

You can also buy DV tapes that have in-cassette memory (CM, MIC, or IC) to help you easily locate and go to the last spot you recorded. IC memory tapes might be a good choice for you if you swap tapes often among different projects and want to maintain an unbroken timecode. But if you tend to leave the same tape in the camera until it's full, and your shooting sessions tend to be long and unbroken, the extra expense of IC tapes isn't necessary.

On the backside of the tape, you'll see a record-prevention tab that you can slide to prevent additional recording on that cassette. Consider using this feature every time you've shot some valuable footage. It will prevent you from accidentally recording over it.

DV tape cassettes are relatively fragile, so try not to drop or bang them. Protect them from heat and moisture. If a recorded tape has been in storage for a long time, you might want to fast-forward it the full length, then rewind back to the beginning. This will help keep the tape in good shape.

*PCM Digital Stereo sound* ❷. Also see Audio recording system earlier in this section. Pulse Code Modulation (PCM) gives you the option of 2-channel, 16-bit stereo (CD quality or higher) or 4-channel, 12-bit stereo (less quality than 16-bit). PCM stereo is extremely high quality and one of the major advantages of the digital video format. The first time this technology was used for a theatrical presentation was with the rerelease of *Fantasia* in 1985 using 2-channel PCM Digital Stereo sound.

*Pixel shift* ❶. This signal-processing technique was once reserved for professional camcorders but now is available on some 3-CCD DV camcorders such as the Canon GL-2. Pixel shift helps achieve a wider dynamic range and improve sharpness by "shifting" some of the green component's pixels (which are 60% of the overall signal, while red and blue combined make up the other 40%).

---

### PRO TIP

RGB is the abbreviation for red, green, and blue, the primary colors of the additive color system. Since these are the colors that computer monitors and televisions use to render images, camcorder management of RGB capture and transmission has a direct impact on image quality. That's why 3-CCD camcorders are usually rated higher and cost more.

---

*Progressive scan* ❶.  Also referred to as noninterlaced video, progressive-scan footage displays all lines in a frame in one pass from top to bottom before the next frame appears. Progressive-scan mode is particularly effective for capturing still images on a video camera, or for computer-only display. Progressive scans don't demonstrate the "jitters" when paused, as interlaced video does.

If you plan to show progressive-scan video on a television, however, you may want to investigate a post-production technique known as field-rendering, which essentially separates the frames into fields so motion and effects are displayed properly on interlaced devices. (For more information, see Image sensor and Interlaced video earlier in this section.)

*Resolution* ❷.  In video, when you see the term "resolution," it usually refers to horizontal resolution, which is the smallest increment of a television picture that can be discerned in the horizontal plane. Generally speaking, this is expressed in scan lines. The more lines of resolution, the potentially sharper and better defined the image. Digital video has much better horizontal resolution (500 lines of resolution) than previous technologies such as Hi-8 (400) and VHS (240). Table 1-4 lists the resolution of several different formats.

Table 1-4: Comparison of commonly agreed upon lines of resolution among various formats and devices.

| Format or device | Commonly accepted lines of resolution | Aspect ratio |
|---|---|---|
| High Definition Television (HDTV) | 1,125 | 16:9 |
| Mini Digital Video (MiniDV) | 500 | 4:3 or 16:9 |
| Standard Television (SDTV) | 350 | 4:3 |
| S-VHS | 400 | 4:3 |
| Hi-8 | 400 | 4:3 |
| 8mm | 270 | 4:3 |
| VHS | 240 | 4:3 |

*Rotary heads* ❸.  DV video tape moves approximately 19 millimeters per second across a drum that contains recording/playback heads. These heads can read and write data tracks diagonally across the tape, a process called helical scanning. The drums rotate at 9,000 rpm. Some DV camcorders use two heads, and others, three.

*Shutter speed* ❸.  In still photography, shutter speed plays a vital role in the delicate exposure balance with aperture setting. For most video recording, however, shutter speed is best left on auto so you can concentrate on other technical aspects of shooting. Typically the auto setting is $1/30^{th}$ or $1/60^{th}$ of a second.

Some video cameras boast high shutter speeds, $1/2000^{th}$ of a second or faster. This setting can be useful for special situations, such as analyzing a golf swing, in which you want to study the motion frame by frame, and you want each frame to "stop the action" and result in a sharp image. You'll need lots of light when using these fast speeds, and it's best to use a tripod so you can squeeze maximum sharpness from your images. Often you'll get jerky playback from footage shot at high shutter speeds, but this isn't much of an issue when studying a golf swing frame by frame.

A slower shutter speed, such as $1/15^{th}$ of a second or longer, can help you capture good footage in low light, Some camcorders set to slow shutter speed capture a series of images and combine them into one. This could result in some blurriness, but it can also be used to your advantage as a special effect.

For everyday shooting, leave the shutter speed setting on auto. But you might want to experiment with how your camera handles fast and slow settings in case you ever want to try them in special situations.

*SMPTE color bars* 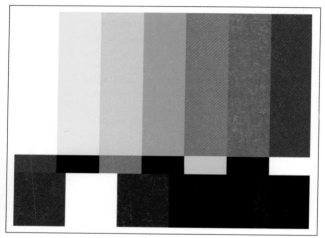. Used to help establish a color reference before recording and playback, SMPTE (Society of Motion Picture and Television Engineers) color bars (see Figure 1-17) are the standard used for NTSC video production. Some DV cameras can generate color bars at the

**Figure 1-17.** SMPTE color bars.

beginning of the tape to enable calibration by professional broadcast engineers.

*Timecode* ⓑ. Digital video camcorders assign a unique number to every frame you shoot, along with hours, minutes, and seconds, all separated by colons. This information is called the timecode, and it's designed to help you find any given frame on the videotape. The timecode is displayed on your LCD screen like this:

00:00:00:00 (Hours:Minutes:Seconds:Frames)

The first three sets of numbers on the left read just like any other time-keeping device. But the last set of numbers, the frames, count to 29, then start over again. That's because video is shot at 29.97 frames per second (fps).

<div style="border:1px solid">

**PRO TIP**

Two types of timecode—drop frame and non-drop frame—have evolved to cope with the lost .03 frame per second speed at which video records. The drop frame spec involves literally dropping agreed-upon frames to compensate for the .03 frame loss, and it is used mostly in broadcast television. Non-drop frame is more common in hobbyist applications and uses the continuous 29.97 fps rate. Unless your work is going to be used for professional broadcast, you don't have to worry about drop frame timecode, but it's good to be aware of what it is.

</div>

You can use the timecode to help you log the scenes on your video tape and find them again in the future. Some nonlinear editors require timecode for editing.

For more information about timecode, see Managing Timecode on page 50.

*Wide screen TV recording* ❶. See 16:9 recording mode earlier in this section.

*Zebra pattern* ❹. To help you identify areas of overexposure, some advanced camcorders display a zebra pattern in the viewfinder, as shown in Figure 1-18. The diagonal stripes indicate a "hot" exposure, giving you the option to make an adjustment.

**Figure 1-18.** A zebra pattern indicates overexposure.

# Putting It All Together

Now that you're familiar with the main features of your digital camcorder, how do you use them to make great video? In the next chapter, How Does It Work?, you'll learn helpful techniques such as how to use special effects, manage time code, and adjust white balance—plus lots more. Great video is only a chapter away.

# 2

# How Does It Work?

In U.S. law, the term "due process" refers to the course of action required to apply justice. Essentially, this means that you can't be accused of a crime and tossed in jail without being advised of the charges against you, and you must then be tried by a jury of your peers. Digital video has its due process, too. And even though the steps aren't as specific as those in the legal world, they contribute just as much to a successful verdict.

Photography is simpler than video in this regard. If you capture an evocative still image, you've done the hard part. All that's left is to upload it to the computer, attach it to an email, and send it out to the world. (This is especially true if you use Apple's iPhoto application.) Friends far away can revel in your success within minutes of you taking the shot.

Video is different. If you shoot some great-looking footage, you still have work to do before it's ready for prime time. How much work depends on the goals and parameters of the project, but the advice here is to keep it simple. As with swift justice in the legal world, fast completion in the editing room is just as important as the finished product. It's not a movie until you finish it, and too many good ideas get bogged down in a complicated process and never see the light of day.

If you adopt the basic approach in this chapter for capturing and managing video, you'll create movies that will impress

friends, family, and peers, and you'll do so with expedience. Plus, thanks to tips on logging and library management, you'll always have an efficient way to retrieve footage, no matter how long ago you shot it.

How does all this magic happen? The whole process boils down to these ten steps:

1. Prepare the tape for shooting.

2. Think light and sound.

3. Manage timecode.

4. Log your clips (maintain a log file).

5. Upload footage to the computer.

6. Edit the video.

7. Add titles.

8. Refine the audio.

9. Back up your master cut and project files.

10. Prepare copies for specific types of output (television playback, web streaming, DVD, archive, etc)

The steps look simple enough, don't they? Here's how they work.

# 1.   Prepare the Tape for Shooting

Get a new video tape, open the box, and pull out the labels. Today is the first day of the rest of your new video life, and *never again will you put an unlabeled tape in your camcorder*. When you get to Step 4, you'll see just how important this is. But for now, write "Source 001" on both the edge and top labels and the month and year on the top label. Then adhere them to the tape cassette.

Once you've loaded the tape in the camcorder, point the lens at a blank wall and record for 10 to 15 seconds. This is called bumping the tape. You're creating a valuable cushion zone at the front of your tape that will help you maintain timecode if you rewind back a tape over the first sequence.

Next, find the Display button and make the timecode visible on the LCD screen. At this point it should read something like 00:00:15:05. Rewind the tape a second or two so the timecode reads something like 00:00:12:21.

Many filmmakers prefer to "format" the entire tape as outlined in Step 3, Manage Timecode. This is often referred to as blacking a tape. That approach works fine too. But if you find yourself in a situation where you need to shoot right away and don't have time to format the entire tape, use the bumping the tape technique to get up to speed quickly while still maintaining your timecode.

Also, leave the camera running for a few seconds at the end of the scene. This creates another bump zone that helps you maintain the timecode. If you rewind to review the scene you've just shot, resume taping the next scene in this bump zone.

Finally, make sure you have an extra battery in your pocket. Now you're ready to shoot.

# 2. Think Light and Sound

At this point you should be thinking about two things: light and sound. These are the foundation blocks of your movie.

When you're studying the first scene you're going to shoot—whether it's on a soccer field or inside a school auditorium—your first thought should be, "How much light is available?"

Quality video requires decent lighting. The more light, the better the pictures. It's true that you can enable "super night mode" on your camcorder to capture the scene (and sometimes

you'll have to). But compare footage shot under those conditions with footage shot outdoors in ample light. You will see less noise and fewer annoying artifacts in the scene shot with the better lighting. In camcorder-speak, the recommended illumination is 100 lux or more for normal shooting mode.

To give you an idea of what kind of lighting 100 lux is, you can use this rule of thumb: 100 lux is very bright indoor lighting or a very dark outdoor lighting. (See Figure 2-1 for a pictorial representation.) To help you further position the 100 lux rating, an overcast day is 1,000 lux and twilight is about 10.

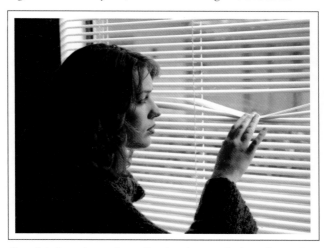

**Figure 2-1.** Camcorders usually record best in environments that have at least 100 lux illumination, which is considered bright indoor lighting. This image represents exposure areas where camcorders do well (face, hand, window) and typical difficult areas (back of hair, sweater, and wall).

So look for the best light available. Given a choice between two locations, choose the one that comes closest to the 100 lux rating. If you can't find an area that bright, or if you just don't have control over the lighting, you'll have to decide between enabling the low-light mode on your camcorder or adding a video light or two.

To help you determine ballpark lux ratings in typical lighting conditions, see Table A-5 in the Appendix on page 99.

Once you've done the best you can with lighting, now think audio. The old filmmakers' saw "Sound is half the picture" remains true today. One of the great ironies of DV movie-making is that you have a full stereo-quality audio-recording system at your fingertips, but many people use a $2 microphone to input sound into that system. In other words, avoid the on-camera microphone at every opportunity.

Use an external microphone (see Figure 2-2), either wireless or with a cord, to capture the audio during taping whenever possible. Resist the urge to go the easy route and use your onboard mic. Not only is it of less quality than a good external microphone, it will also pick up noise from the camcorder's drive mechanism.

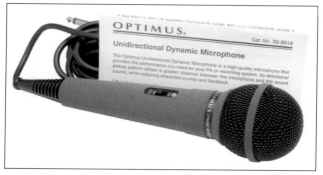

**Figure 2-2.** Use an external microphone whenever possible for the best sound recording.

If an external mic is impractical for a given situation, put a microphone in the camera's accessory shoe to record sound. Most camcorder manufacturers provide accessory mics for this purpose. The sound might not be as good as a lapel mic for an interview or an external mic on a boom for dialogue, but the audio will be superior to the sound recorded by the

on-camera mic that is picking up the grind of the camcorder motors.

Recognize that the lighting and audio won't be ideal for every scene you shoot. We're not talking Hollywood here. But if you get in the habit of thinking about light and audio up front, making the best decisions possible given the circumstances, your videos will be heads and shoulders above those of your peers.

---

**PRO TIP**

When you're shooting on location—at the ocean, a sporting event, or even in a quiet room—make sure you capture an ambient sound track. Aim the camera at a fixed point and let it record the environment for a minute or two. Later, when you're in production, you can use these ambient sound tracks to provide "clean" background noise for your various scenes.

---

## 3. Manage Timecode

There are two ways to look at timecode management: Either it is the most important tool since felt-tip markers, or it just doesn't apply your video lifestyle. The reality? Timecode is important, and you need to manage it. The good news is that it's easy to do.

Timecode is the language of video. It's the system your camera uses to assign a unique number to every frame you shoot, enabling you to accurately log your scenes and find them later without burning out your camcorder's drive mechanism shuttling back and forth in search of that elusive magic moment. Clean timecode is also required by many video-editing applications for batch processing. Even if the application you're using now doesn't need clean code, as is the case with Apple's iMovie, another might, such as Adobe Premiere.

The danger is that if you're not aware, you can break the time-code and thereby break your ability to log and manage scenes. (If you need a refresher on how to read the numbers, see Timecode on page 41.)

Once you've begun using a tape for recording, remember this rule: *Black or blue screen is bad*. If you record a scene, replay it, accidentally let the camcorder keep running until you hit blank tape (where the screen turns blue or sometimes black), then start recording again from that point, you will break the timecode.

This leads to a second rule: *Bumping is good*. If you bump for 10 seconds or so at the beginning and the end of a scene, you have a nice cushion to return to when you want to resume recording. Since you're not starting the next scene on blank tape, your timecode will remain intact.

---

**PRO TIP**

Since unbroken timecode is of vital importance to professional cameramen, sometime videographers will black the tape before they go out on location. They simply load a brand-new blank tape into the camcorder, put the lens cap on, mute the sound, press the record button, and let the tape roll for its duration. Now timecode has been established for every second on that cassette. Then they simply rewind the tape, label it and the box, and they're ready for assignment. No matter what happens during the excitement of shooting, the timecode will remain unbroken.

---

Most camcorders have a function called *End Search* or *Record Search* that enables you to find the end of the last scene captured on tape. Technically, you can begin recording from this point without breaking the timecode, but it never hurts to rewind a second or two into your "bump zone" just to be sure.

# 4.   Log Your Clips

If you've done a good job of labeling your tapes and managing your timecode, building the logbook is easy and, to be honest, fun.

The process is very simple. You create a log-page template (see the Appendix for a sample log sheet) that includes column heads for *Start Time*, *Date*, *Project*, and *Description*. Then, after a day's shooting, sit down with your camcorder, pull out a fresh log sheet, and play back the tape. Every time there's a scene change, note the timecode and write a brief description for that scene (you can fill in the date and project label later). You can maintain your log pages on your computer, print out templates and store them in a three-ring binder, or both.

In Hollywood there's a tradition called watching the dailies. Basically, it involves the director, producer, actors, and some crew members getting together to review the previous day's shooting after the film has returned from the lab.

Even though your "film" doesn't have to go to a lab, watching the dailies is a worthwhile habit. And while you're doing so, have a clean log sheet handy to annotate the scenes.

Once you start logging your scenes, you'll get addicted to the process. Being able to find the exact spot on a tape where any given scene exists, without having to shuttle back and forth, is an empowering experience. And if you keep your log sheets on the computer, you can use its search function to locate a scene even faster.

Log sheets save time, avoid frustration, prevent loss of valuable footage, and extend the life of your camcorder's drive mechanism.

# 5.   Upload Footage to the Computer

Once you've logged your scenes, you're ready to upload them to the computer for editing and post-production. Before you begin the actual transfer process, here are a few tips to make sure your workstation is in order:

- Check your available hard-disk space. Digital video requires approximately 1 gigabyte for every 4.5 minutes of video capture. If you have 35 minutes of footage to upload, make sure you have 8 GB of space available. You'll need 13 GB for a full hour of video.

- Make sure your camcorder has a fresh battery or is plugged into a power source. You don't want to run out of juice in the middle of a capture.

- Keep your log sheet handy for quick reference.

- Check your FireWire connections (Figure 2-3) to make sure your camcorder and computer are "talking" to each other.

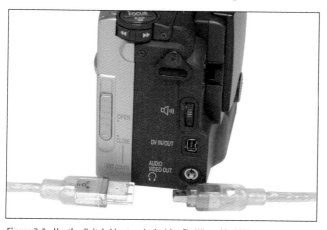

**Figure 2-3.** Use the digital video terminal with a FireWire cable (IEEE 1394) to transfer high-quality video and sound to your computer for editing. The smaller connector on the cable connects to the camcorder, and the larger end is for the FireWire terminal on your computer.

Now you're ready to copy the video from the camcorder to the computer (the original footage remains on your source tape so you can tuck it away for safe keeping). Depending on your software, there are two ways to accomplish this: batch processing and capture on the fly.

Batch processing is more common on sophisticated editors such as Adobe Premiere and Apple Final Cut Pro. This method involves watching the movie on your computer screen (the PC actually controls the camcorder) and "marking" where each scene you want to capture begins and ends. (This method requires clean timecode.)

Once you've marked all the scenes you want to import from camcorder to computer, you initiate the Batch Capture command. The computer takes over, automatically capturing all the scenes you've marked and copying them to the hard drive.

Capture on the fly is the method that iMovie, Movie Maker, and other consumer-oriented applications use to grab video. You simply start watching the tape on your computer screen, and when you see a scene you want to capture, you click a button and the computer copies that sequence to the hard drive until you click the button again to stop the recording. The raw footage keeps playing as you start and stop the uploading process.

Each method has its strengths. Batch processing allows you to zoom through your footage, marking the start and stop points for each scene, and let the computer do all the work while you go have a cup of coffee. Capturing on the fly doesn't require timecode management, premarking, or using software that has a steeper learning curve. You simply review your footage and tell the computer what to copy while you're watching. Capturing on the fly is also easier on your camcorder because you're not starting, stopping, rewinding, and fast-forwarding as much.

Generally speaking, if you're new to DV editing, you might want to start with a capture on the fly system to get your feet

wet. Regardless of the editing software you settle on, remember to always manage your timecode while shooting. You may use entry-level software today, but tomorrow you may want to tap those same source tapes again with a more sophisticated system, and clean timecode gives you that option years up the road.

# 6.    Edit the Video

Not everything you shoot needs editing. Some projects, such as a short interview, may simply require a little trimming and adding a few titles.

Those projects are rare, however. Everything else will have to go through the process of *selecting*, *trimming*, and *rearranging*, otherwise known as editing the video. Before sitting down at your computer to begin this, take a moment to peruse your log sheet. Review the various scenes you've captured and think about how they might best be arranged to tell a story. Can you construct a beginning, middle, and end to your movie?

Once you have a feel for the story you want to tell, assemble the rough cut. Arrange scenes on the timeline to create the basic flow of the story. Many times you'll find that you need to trim a scene before incorporating it with the others. Don't get too hung up on fine-tuning at this point. Make your trim and move the scene to the timeline. You'll refine it later.

Now watch the "first draft" of your movie. Is there a narrative? In other words, does it tell a story? One of the most effective techniques for constructing a compelling narrative is first to "hook" viewers with a intriguing scene, then slowly draw them into the story though compelling events, settings, and characters.

If you're reporting on your son's birthday party, for example, use this technique to make your short movie as memorable as the event itself. When you're watching the rough cut, keep narrative in mind. Begin the movie with a particularly humorous

moment, perhaps, such as the dog licking frosting off your son's face. Now that you've created an interesting hook, arrange the rest of the scenes into a pleasing story. Remember, you're going to love this movie because the star is your son. But can you make it compelling for others too?

Once you have the building blocks of your narrative in the right order, go back through each scene and make sure it reads—the term for trimming footage so it plays on the screen for just the right amount of time. Wide-angle scenes with lots of activity must play for longer than close-ups because viewers have more visual information to assimilate. How long a scene plays is a matter of creative judgment on your behalf. This is an opportunity for you to express your vision and style through the editing process. But don't get carried away with trims that are too drastic or too soft. Make sure each scene is interesting and compelling in and of itself, and that it contributes to the whole of the story.

As you think about how to transition from scene to scene, remember that keeping it simple is the best approach. Let your scenes and characters carry the story, and don't rely on post-production wizardry to salvage a weak narrative. The simple cut is still the preferred method for moving from one scene to

the next. This means that your film moves from one setting to another without using a computer-generated transition such as a dissolve.

A very powerful short movie could be constructed like this: fade in, cut, cut, cut, cut, cut, cut, cut, fade out. "Clean and simple" is a mantra worth repeating at the editing bay.

This is not a hard and fast rule by any means, however. Transitions certainly have their place in quality productions. Dissolves, for example, are good for showing a transition of time. And wipes are helpful for conveying a change in location.

As you work on your video, keep an eye on the total length of the piece. You may be surprised to read that most home movies should run between 2 and 5 minutes, and no longer. Why? First of all, it's difficult to shoot enough compelling content for a longer movie. Also keep in mind the attention span for most of your viewers. Consider people's viewing habits these days:

- Television commercials run 15 seconds to a minute.

- News spots generally last 1 to 3 minutes.

- 30-minute television shows are divided into 3 segments of less than 10 minutes each.

And this is work created by a highly trained team of professionals.

Speaking of professional work, watching how the pros shoot and edit movies, television shows, and commercials is an excellent way to improve your technique. You'll be surprised at how different these productions appear to you once you start to analyze how they're created.

When you get to the editing bay, be merciless in your trimming. Take only the moments you need to build a compelling narrative, and leave the rest in the archive. Create a powerful beginning, develop your characters in the middle, and tie

everything together in the end. Use simple cuts and clean titles.

As you hone your movie-making prowess, you can take more chances and push the boundaries of your storytelling. But let your creative voice emerge through practice and refinement.

Now that you've shaped your video into an interesting story, it's time to add a few titles, then complement the pictures with equally appealing audio.

## 7.  Add Titles

Becoming overzealous with titles is another way to show your audience that you're new to movie-making. As with other effects, it's best to show restraint at this phase.

Generally speaking, you'll want an opening title to set the tone for your movie and possibly a closing title or two to wrap things up.

The basic steps for creating a title are as follows:

1. Type the text.

2. Select the font, size, color, and typography effect (such as drop shadow).

3. Choose the title animation (fade, fly-in, zoom, scroll, etc.).

4. Establish the background (black, still image, or video).

5. Set the duration for the title.

Most video editors provide a separate environment for creating titles. You then position the title clips on the timeline at the appropriate locations.

Beware of effects such as flying letters unless they achieve a specific goal. As with the rest of post-production, simple is better.

Here are a few tips to help you build more effective titles:

- Make sure your type is large enough to be read on dim screens such as cheap televisions.

- Most sans-serif fonts (such as Ariel, Verdana, and Helvetica) are easier to read than serif fonts (such as Times and Palatino).

- Leave the title "on screen" long enough that viewers can absorb the information.

- Typically, white or brightly colored type on a dark background is easier to read than the other way around.

- Be aware of the "television safe zone" and keep your titles within that area. It's usually about 80 percent of the overall screen real estate in the center. This allows for discrepancies from TV to TV.

- Centered titles are safer than those in the corners.

---

**PRO TIP**

Every video editor allows you to add effects to your titles. Most of them you should ignore, but a widely accepted effect is using a fast fade to bring in and exit the text. It looks good and is easy to do.

---

Once you've added your titles, you're now ready to refine the audio.

# 8. Refine the Audio

Sound is indeed half the picture, and if it's bad, it seems like more. Poor audio is a common distinguishing characteristic of amateur filmmaking.

Consider this: If you watch a movie that is grainy or has unusual, muted colors, you'll probably think that the

filmmaker has created that look on purpose for mood and effect. But if the same movie has inaudible dialogue and tinny ambient sound, you'll think that he just doesn't know what he's doing. Viewers will give you the benefit of the doubt with video, but not with audio.

If you've recorded decent dialogue or ambient sound for your movie, you're halfway home. Now that you're working at the editing bay, you can refine your audio so that it "carries its weight" in the final production.

You should refine the audio after applying titles because you'll often want music during the opening and closing text. If you save titles for last, you have to go back to the audio to finish your movie. Instead, it's much easier to get all your video tracks in order, then refine the sound.

There are three basic types of audio tracks you'll use for this phase:

*Dialog.* This category includes the sync sound you recorded while taping, voiceover narration, and ambient background sound. When working in your video-editing program, the dialog track will occupy most of your time.

*Effects.* You may want to add a sound that wasn't part of the original recording, such as water running in the background, a ticking clock, or a car driving by an open window. Video editing applications often include a "starter set" of audio effects, and you can add more as needed by your project.

*Music.* For some projects, adding a music track during specific scenes can enhance the mood or reinforce the message being conveyed by the video. For personal projects, you can take music from your CD library and add tracks to your movie. If your project is destined for public viewing, you should use royalty-free music or secure permission from those who own the rights to the music you want to use.

Once you've decided on the audio elements you're going to include in your project, the next task is placing them on the timeline and balancing their volumes.

Generally speaking, dialog tracks should be set to a higher volume, with sound effects and music more subdued. Often you may want to use "fade in" and "fade out" controls for your music tracks so they gently move in and out of the viewer's awareness and don't draw too much attention away from the dialog and video.

As a scene winds down, you may want to let the music linger a few seconds after the video has faded to black. This prevents an abrupt ending to sound and video at the same time.

Keep in mind that you'll have to make all of your separate audio track adjustments with your video editor. Once you export your movie back to tape or to QuickTime, the audio tracks are merged into one, and you can no longer adjust them individually.

---

**PRO TIP**

Two widely used audio editing techniques are J-edit (dialog begins before the video starts) and L-edit (video begins first). A typical J-edit happens at scene transitions in which the dialog for the next scene begins while the viewer is still watching the last few frames from the previous scene.

It's easy to create a J-edit with most editors. Simply highlight and cut the last few seconds of the first scene, then move the playhead to the beginning of the second scene and use the "Paste Over at Playhead" command. Give it a try. It's an easy way to add a professional touch to your movies.

---

More sophisticated video editors include a variety of audio controls and filters. Regardless of whether you're using something as simple as Movie Maker or iMovie or an editor as powerful as Adobe's Premiere, keep in mind that your job in

the editing room will be much easier if you've recorded high-quality audio to begin with.

# 9. Back Up Your Master Cut and Project Files

Now that you have your movie playing the way you want it to (at least for the time being), you should back it up to preserve your time investment. There are two ways to do this: the master cut export to tape, and the project files backup to disc. You may adopt either or both depending on your setup and level of comfort (i.e., paranoia).

The first method, master cut export to tape, involves recording your master cut back to a fresh tape in your DV camcorder. Since there's no quality loss moving from camcorder to computer and back to camcorder, you can make as many master cut tapes as you need. For example, you might want to make two tapes, one for your home library and one for off-site storage.

Up the road, you could upload your master cut back to the computer to burn DVDs and CDs, export to QuickTime, and so forth. The thing to keep in mind is that all of the various tracks that you created in your editing program will be combined during export into two basic tracks: audio and video. So if you created ambient, voiceover, and music soundtracks in the video editor, they will now be just one audio track, and you can't pull them back apart.

This is why you might want to consider the second method of backup too: project backup to disc. In this case, you copy your entire project folder to a blank DVD (see Figure 2-4). The advantage of this method is that if you ever experience a hard-drive crash or accidentally delete your project folder, you can reload the entire movie, with all of its tracks, from the DVD into your editing application.

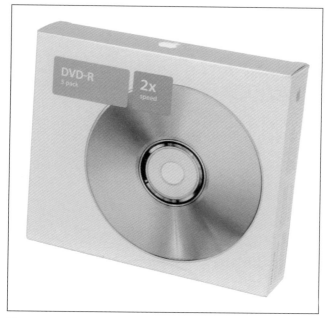

**Figure 2-4.** DVDs are not only good for sharing the final project with your viewing audience, but they also make excellent media for backing up your project files.

Once you've done so, you can adjust individual tracks, add clips, change transitions—you have complete control over remastering your movie.

Some home movie-makers back up their project files to a separate FireWire hard drive as a temporary solution. This is fine as long as your original project files are still residing on your computer. But don't entrust your valuable work to a separate hard drive as a long-term solution. Once you're ready to move the project off your computer, make a master cut tape as minimum protection, and an additional project folder backup to DVD if possible.

Windows PC users might want to take a look at GEAR DVD ($79 U.S.) for powerful and flexible DVD burning. It works on all Windows operating systems starting with Windows 95 and supports most DVD burners. Roxio's Easy CD and DVD Creator software ($79 U.S.) is also popular for the Windows users. And consider Ulead's DVD MovieFactory ($49.95 U.S.) for entry-level DVD authoring.

If you're using Mac OS X, basic CD and DVD burning software is built right into the operating system. For more flexibility, take a look at Toast 5 Titanium by Roxio ($99 U.S.), which enables just about every type of CD and DVD burning need you'll have. And for building menu-driven DVDs, Apple's free iDVD is tough to beat.

# 10. Prepare Copies for Specific Types of Output

The beauty of digital video is that you have so many ways to share it with others. Now that you have your movie edited to your satisfaction and have backed up at least a master cut, you can export it to one or more of the following formats:

*DV tape (digital video).* Yes, you've made a master cut backup, but that's tucked away safe and sound in your library. A second export to DV tape that you carry around enables you to plug your camcorder into any television and play your movie full screen with CD-quality sound.

*DVD.* Your movie is exported to MPEG-2 format and can be viewed on most set-top players and computers. Regardless of which platform you use to create the DVD—Macintosh or Windows—the audio and video is capable of the same high quality that you see on commercial discs. Because this is a widely accepted standard, DVDs are a great method for distribution to family and friends.

*VCD (Video Compact Disc).* This variation of a standard CD-ROM uses the MPEG-1 format to encode your movie. Since you're using regular CDs, you have less disc capacity than with DVDs, and the quality is not as good. But VCDs can generally be played on most computer CD drives, VCD players, and some DVD players.

*SVCD (Super Video CD).* Basically, this is an enhanced version of VCD that uses MPEG-2 encoding and has variable bit-rate capability. You're still exporting to CD, so your runtime is limited to 20 or 30 minutes. And you have to make sure that recipients of these discs have software to play them on their computer or that their set-top players can decode them.

*VHS tape.* Most DV camcorders enable you to transfer your movies from DV to VHS by connecting the camcorder to a VHS recorder. There is some quality loss using this method, but it's a great way to share your work with those who are still using analog equipment.

*QuickTime.* The QuickTime format, *.mov*, is cross-platform and plays equally well on Windows and Macintosh computers. You can export your movie to QuickTime and burn it on CDs, put it on a web page, or attach it to email (if the file size is small enough—usually 1 MB is the accepted limit).

*Streaming video.* Some editing programs, such as Ulead's VideoStudio 7 for Windows, allow you to export your movies to streaming formats too, such as Windows Media Video (*.wmv*). Keep in mind that you need a streaming web server to share this content, and there are compression and bandwidth considerations to keep in mind while preparing your files.

The easiest way to share your work with others is to copy it back to DV tape and plug your camcorder into a television. But

it's good to know that digital video affords you a variety of options, and that once you've finished your project, you'll be able to show it to just about anyone who has an electrical outlet in their home.

## It's a Wrap!

Your filmmaking prowess is growing. You've mastered the controls on your camcorder and understand the steps involved with producing a movie from start to finish. Now it's time to forge into new frontiers.

In Chapter 3, you'll learn some of the advanced techniques that will give you movies that look and sound professional. Like magic, it's really very simple once you know the secrets.

# 3

# How Do I...
## Tips, Tricks, and Techniques

If the fundamentals you read in the earlier chapters are the concrete slabs and wood floors of your movie-making, the following tips and tricks are the spiral staircases, bay windows, and crystal chandeliers. You know you need the foundation, but you *want* the built-in Jacuzzi.

This chapter is about how to do the fun stuff—quickly light a scene, capture sports action, survive a wedding, and convert your footage to QuickTime for web publishing. It's an overview of why you were drawn to video in the first place: to make magic and impress others.

These tips and tricks are divided into three sections: Outdoor Shooting and Action Video, Indoor Situations and Special Events, and In the Editing Room. In the first two sections, you'll see how to take lights, reflectors, microphones, monopods, and gaffer's tape and use them to capture footage that you never thought was possible with a $500 camcorder. Then you'll finish out the chapter by returning to the computer to learn about QuickTime and DVD production.

Will you know everything you need to know about video magic once you complete this chapter? Of course not! That takes more information than can be contained a book not big enough to keep your bottom warm on a cold park bench. (Come to think of it, you might get the *Digital Photography*

*Pocket Guide* for the other cheek.) But over the next few pages you'll learn techniques that will change the way you make movies.

# Outdoor Shooting and Action Video

Here are some tips for shooting outdoor and action video.

## Tip 1: How to shoot action video like a pro

When you think about shooting video, most likely you're thinking about recording motion—capturing someone or something moving. Of course! You're not going to make a movie of a flower arrangement sitting in a vase. So, if recording motion is the essence of video, why do so many home movies make viewers queasy?

The problem is that many DV enthusiasts don't understand how to "hold the shot." In other words, it's the subjects who are supposed to be moving, not the camera.

This error is particularly common in "action" videography, where the cameraman is hand-holding the camcorder and trying to follow the play at an event such as a soccer game. Obviously you have to move the camera some, or you'll never record any of the play on the field. But it's the "how" you move the camcorder that's important.

Most professionals mount their camera on a tripod for this type of assignment. There is no better way to steady a camcorder than to secure it to a rock-solid tripod with a fluid head. But that probably won't be practical for much of the shooting you do. In the real world, people are already schlepping way too much stuff, and a bulky tripod could be the straw that breaks daddy's back.

You could instead spend a few hundred to a thousand dollars on a steadicam that enables you to move freely while shooting.

But that's unlikely too, unless you're going to be selling your soccer films to Hollywood for some serious cash.

The real-world answer is a simple, compact, and very effective accessory called a monopod. Essentially, it's a one-legged tripod. Even though they are extremely compact and easy to transport, monopods are an excellent tool for helping you properly hold your shots. Your footage will improve immediately.

Once you have your camcorder steadied, here are the basic types of shots you should be considering for recording action video:

*Entrance and exits.* Anticipate the direction of the action, frame your shot, let the subjects enter the frame, follow them for a short period, then let them exit the scene.

*Panning.* Once the subject has entered the frame, you can follow her horizontal movement. Mounting the camcorder on a tripod or monopod is very important for this shot because jerky camera movement ruins the effect. Keep in mind the 180-degree rule while panning: never cross the imaginary horizontal line that comprises your field of view once you've begun the shot. If you're shooting at a soccer game, for example, the two goal posts are your 180-degree markers.

*Tilting.* Basically this is the same as panning, but you're moving the camcorder in a vertical motion instead of horizontal.

So now you have a feel for how to shoot your sequences. If you can, mount the camera on a monopod. If you don't have one with you, hold the camera as close as you can to your face, lock your elbows against your body, and pivot from the waist. Let the action enter the frame, pan for a short period of time, then let the subjects exit the scene (see Figure 3-1).

**Figure 3-1.** When shooting action shots, allow the subject to enter the frame, then pan the camera to follow her. Leave a "comfort zone" in front of the subject in the direction she's moving.

What about zooming? The zooming range of today's consumer camcorders is nothing short of amazing. Those lenses allow you to get close to the action for compelling shots.

Rule one is to use the zoom to frame the shot, *then start recording*. Generally speaking, try not to zoom during the shot. There are a few exceptions that will be covered later in this chapter, but action photography is not one of them.

If you add zooming to the shooting technique described above, your sequences might flow like this:

- Zoom the lens to frame the shot.

- Anticipate the direction of the action and start recording just in front of it.

- Let the subjects enter the frame.

- Pan the camcorder to follow the subjects.

- Let the action exit the scene.

- Stop recording.

Then, for your next shot, start the sequence over.

Here's another trick to spice up your action-oriented videos. Take time to shoot cut-in and cutaway footage. Shots such as the coach consoling a player on the sideline or an ankle being tapped are valuable stock footage that you can use to break up the action and give your movie variety.

Don't forget to grab a couple of establishing shots—wider views of the scene that give viewers a feeling for the big picture. Sometimes you might want to add a few seconds of establishing footage at the beginning of the movie to set the scene. This is not a hard and fast rule, but it's good to have this shot "in the can" just in case you want it while editing.

Most importantly, keep quiet while filming. You want to record the ambient audio of the environment, not yourself cheering for—or even worse, swearing at—the players on the field.

## Tip 2: How to shoot the classic walking interview

One of the most compelling ways to shoot an outdoor interview is to record the subject while he is walking (see Figure 3-2). The camera holds the interviewee steadily in the center of the frame while the background just rolls along. This camera technique is called tracking. When done right, an otherwise static shot becomes a vibrant scene in your production. You'll need the following tools for this shot:

- Wireless or boom mic

- Wheelchair (to serve as your "dolly")

- An assistant or two

**Figure 3-2.** The walking interview enables you not only to record the subject in motion while he talks, but also to capture the flavor of the environment.

Here's the basic setup. The audio must be captured through an external mic to avoid distracting sounds such as camera transport, grinding gears, etc. Wireless mics are easiest for this shot and don't require an assistant to hold the boom. Booms, on the other hand, have the advantage of showing no equipment in the footage, such as a lavaliere mic attached to the shirt collar of the subject. Boom mics do require a set of extra hands, though.

The wheelchair, often referred to as a poor man's dolly, is the key component here. The cameraman sits on the chair—most likely with her butt on the back of the chair and her feet on the seat—and is pushed slowly and steadily by an assistant alongside the interviewee during filming.

This provides a quiet, continual transport that rolls along at the same speed that the subject is walking. Obviously, the smoother the surface is, the steadier the shot. So when you're scouting locations for this type of scene, look for areas that have relatively smooth surfaces that are wide enough to

accommodate a wheelchair and subject moving side by side about four feet apart. An interesting (but not too busy) background is important as well. Also pay attention to the position of the sun—which is why it's valuable to scout a scene at the same time of day that you're actually going to shoot it. Ideally, the sun will be illuminating the subject's face, but not shining directly in his eyes.

Used wheelchairs are easy to find at second-hand shops and garage sales. It doesn't need to be fancy, just roll smoothly and fold up for easy transport.

---

**PRO TIP**

To limit depth of field when shooting interviews outdoors, try adding a neutral density filter that will force the aperture to "open up." These filters are available in a range of densities, usually 1 to 4 f-stops. The darker the filter, the wider the aperture and the softer the background. If you already have a polarizing filter, that will work too. Polarizers usually have 2 stops density.

---

## Tip 3: How to use reflectors to improve natural lighting outdoors

A basic rule of lighting is that the subject should be at least as bright as the background (unless you're creating a special-effect shot). You'd think this would be a given—that is, until you really start studying the lighting of your scene. Even in bright sun, there can be distracting shadows on the subject's face, or your model may not be illuminated as evenly as you'd like. And backgrounds always seem brighter than you want them to be.

One or two strategically placed reflectors can help you re-direct the light on to the subject for better illumination (see Figure 3-3). This common Hollywood practice involves

mounting large reflective panels on light stands or handholding reflectors to follow the actor's movements.

**Figure 3-3.** Portable folding reflectors, often called Lite Discs, help you quickly redirect light both inside and out. In the top photo the subject is displaying the Lite Disc, but no light is being redirected. In the bottom image you can see a noticeable difference in the model's clothing and skin tones due to the reflected light.

Carting around large rigid panels isn't practical for most hobbyists, but having a collapsible "photo disc" or two tucked away in the trunk of your car can save the day. With an extra

How Do I...

set of hands (or a stand to mount the reflector on), you can redirect sunlight to better illuminate your subject. Photo discs have reflectors on both sides, usually silver for maximum reflection and gold to warm up skin tones. When you place the reflector, keep in mind that it should be opposite the main light source for best effectiveness.

If you don't want to spend the extra dollars for collapsible discs, a low-budget alternative is to go to the local office supply store and purchase a few sheets of white poster board. This option isn't quite as portable or durable, but you can buy lots and lots of poster board for the price of one collapsible disc, and it works just as well.

## Tip 4: How to overcome backlighting

One of the most common mistakes in amateur filmmaking is capturing footage of a backlit subject. Often this happens while panning, when a brightly lit background enters the frame. Everything in the foreground suddenly turns dark as the camcorder's metering system measures the bright sky or light streaming in through an open window. See Figure 3-4.

There are three basic ways to combat backlighting:

- Use a reflector or video lights to add illumination to the subject.

- Lock your exposure on your subjects so they don't silhouette when the camera pans to a backlit scene.

- Avoid this lighting all together.

Reflectors and video lights are helpful in backlit situations where you want to balance the background with the subject. A common scenario is one in which you place the camera on a low angle and shoot upward at the subject with a beautiful "fluffy-cloud sky" in the background. You want to capture both the sky and the subject.

To do so, you'll need to add enough light to your model, with reflectors or video lights, so that both the sky and the subject have about the same level of exposure.

**Figure 3-4.** Watch out for backlighting! In the top figure the camcorder set its exposure according to the light coming in the window, which underexposed the subject being interviewed. In the bottom figure, exposure was locked in on the background, but light was added to the underexposed subject to balance the overexposure.

If you don't care about preserving detail in the background, such as when filming in front of an open window, use your camcorder's exposure compensation control to lock in the exposure on the subject. Your model will remain adequately

exposed, but the background will "blow out"—in other words, become bright white with no detail.

You may have thought that option three, avoid backlighting all together, was a flippant suggestion. Actually it's not. Once you understand what causes backlighting—when the background is much brighter than the subject—you'll find that simply changing your camera position to avoid it is the easiest solution of all.

## Tip 5: How to cope with wind

Wind is seldom the videographer's friend, especially when trying to record clean audio outside. Even a little breeze can create "wind noise" as it blows across the microphone and ruins the synchronized audio track. See Figure 3-5.

Figure 3-5. Even a little wind can interfere with capturing clean sound outdoors.

The best solution for wind is to avoid it. If that's not an option, investigate the different types of wind screens that might fit your microphone. "Foam socks" (sometimes called windsocks)

usually cost less than $50 U.S. and protect the microphone from the elements, while still allowing recording of dialog and ambient sound. For about twice the cost of foam socks, you can get high-performance fabric mesh screens. Sometimes these are referred to as "furs." Fabric mesh screens can deaden up to 20 db of wind noise, making them more effective than their foam counterparts.

If you find yourself in a windy situation without a windscreen, here's a trick you can use to salvage the ambient audio. Shoot your video, then find a sheltered place nearby where you can shield the microphone from the wind. Set your camcorder to record and capture a "wind-free" ambient audio track lasting as many minutes as you need to accompany the video you just shot.

When you're back at the computer in the editing room, you can remove the windy audio track that accompanied your video and replace it with the "wind-free" track. Remember, it's not the sound of the wind itself you want to avoid; it's the static-like sound of the wind hitting the microphone that's distracting. If you find a place you can protect the mic but still capture the ambient sounds of the scene, you're in business.

# Indoor Situations and Special Events

Continuing on, here are some essential tips for indoor situations and special events.

## Tip 6: How to corral color temperature

You don't need a degree in physics to corral color temperature indoors, but it helps to have a basic understanding of how different light sources can affect the appearance of your video. For example, if there's an eerie green glow in the background of your shots, you may want to know what's causing it and, if you don't like it, how to get rid of it.

The vocabulary for the "hue of light" is in terms of color temperature. Color temperature is described in degrees Kelvin (K), in large part thanks to 19th-century British physicist William Kelvin, who heated a block of black carbon and noted the varying color changes at different temperatures. You should note that degrees Kelvin doesn't have anything to do with the temperature of the environment in which you're shooting. Instead, it refers to the heat required to make Kelvin's block of black carbon change color.

You can see a detailed listing of light sources and their corresponding degrees in Kelvin by referring to Table A-1 on page 97.

For the most part, we don't notice subtle color shifts in our environment as we move from indoors to out because our optical nervous system compensates for the changes. Video camcorders attempt to do this also when set on "automatic white balance," but sometimes they need a little help to get the color balance just right.

To help you get your bearings, here are a few reference points. The standard for daylight color is 5500K, the hue of midday sunlight on a cloudless day. Indoor lighting is usually in the 3200K neighborhood, or the equivalent of a very bright tungsten light or quartz bulb. These color temperatures are constantly changing both inside and out. For example, when the sun rises, it's only about 1800K, climbing to over 5000K at noon, then declining again to less than 2000K as it sets.

There are times you might want to adjust color balance outdoors, such as on a cloudy day when the hue is "coolish," or has a blue cast. But most of the real color headaches are indoors (hence this discussion in the "Indoor Situations" section) because of mixed lighting.

The advantage of outdoor lighting is that you only have one light source to contend with—the sun. Your camcorder, when set to automatic white balance, doesn't even work up a sweat dealing with situation. It just makes the correction. If you want

to override your camcorder's decision, you can work with the color adjustment icons such as "cloudy" or "daylight." A single light source makes things much easier.

Indoors can be a different matter all together. You might have fluorescent tubes overhead, video lighting directed at the subject, and daylight streaming in the window.

Entire books have been dedicated to coping with this very problem, but a few hints can help you capture good-looking footage with minimal headache.

*Limit your light sources.* If you're taping an interview or some other scene where you don't need to capture much background information, set up your video lights and turn down the other sources. If you're next to an open window, look closely at how that light is affecting the scene. Is it causing a bluish tint in the shadow areas? Either draw the shades or warm it up by adding a tungsten source. Generally speaking, though, the fewer different types of lights you have to deal with, the fewer headaches you'll have.

*Use your camcorder's white balance settings.* Before you start shooting the actual footage, take a few moments to play with your white balance settings to see which looks best on your LCD monitor. If the dominant light source is overhead fluorescent tubes, for example, you might have a choice of fluorescent white balance settings (to adjust for cool white tubes, daylight tubes, etc.). Try the different settings and see what looks best. If you can't get the hue to your liking, try using the manual white balance adjustment.

*Consider gels for tricky mixed-light situations.* A typical mixed-lighting problem is shooting indoors with fluorescent lighting above. Instead of turning off all those lights and losing the ambience of the setting, add a 1/2 CTB color correction gel to your tungsten lights, then use your camcorder's manual white balance adjustment to correct

for the overall scene. Both subject and background should have a pleasing hue.

Learn to identify different light sources and pay attention to how they look in your LCD monitor. The biggest challenge for many people is learning how to see the environment as the camcorder sees it, not as your eyes and brain perceive it. Often a few small adjustments can make a world of difference in the final footage. "Think like a camera," and your movies will look better.

## Tip 7: How to choose the right video light setup

As you've read earlier, when you can shoot with natural light, do it! Artificial light for videography increases the pain quotient substantially. But there are certain types of scenes, such as the *60 Minutes*–style of interview, where Mother Nature just won't get the job done.

But what kind of lights should you consider? You have lots of choices here, but your pocketbook will probably be the ultimate guide. Here are some of the more popular lighting options:

*Photoflood.* These tungsten lights are some of the most affordable you'll see in the camera store. You can usually get kits that include two 500-watt bulbs, reflectors, stands, and a case for $150 to $300 U.S. They're not beautiful, and they emit lots of heat, but photofloods get the job done.

*Quartz (3200K).* Often these kits provide you with a "key" light (around 600 watts) and a "fill" light (around 250 watts), plus stands and reflectors. They cost in the range of $200 to $600 U.S., depending on the configuration. Quartz lights are brighter and more compact than photofloods, but they get just as hot.

*Mini Cool-Lux (3200K).* These brand-specific, tiny quartz-halogen bulbs are designed to burn much cooler than

traditional quartz and photoflood lamps, and they typically produce more light at lower voltages, too. Kits cost a bit more than quartz and photoflood, but they are often worth the extra dollars for their compactness and reduced heat output.

*HMI lights (Halide Metal Iodide—5600K).* Flicker-free and daylight-balanced, HMI lights are near the top of the lighting food chain in terms of quality and cost, but be prepared for a four-digit price tag per light. Why? HMI bulbs contain mercury vapor, argon gas, halogen, and metal oxides, and they require a state-of-the-art electronic ballast (similar to regular fluorescent lights, but more sophisticated) to control their cycles. They produce four times the light of tungsten bulbs of the same wattage, and they burn cooler too because less energy is wasted as heat. They are powerful, flexible light sources indoors, but they can cost more than the camera you're using to capture the action.

*Video fluorescent lighting (varying color temperature from 3000 to 5000K).* The technology for video fluorescents has improved in recent years (primarily due to new-generation electronic ballasts), enabling this light source to gain popularity in television studios and other professional settings. Unlike tungsten light bulbs that produce 25% light and 75% heat, fluorescent bulbs produce only about 5% heat, and the rest is light! This provides a much more comfortable shooting environment for the talent and crew alike. Additional benefits include softer light (no filament) and lower energy costs. These specialty video fixtures run between $300 and $1,200, depending on the number of tubes they hold and their features (such as dimming ability).

What's the best lighting for you? If portability isn't a priority, and you have a moderate budget for this investment, today's fluorescent video lighting is sure to please. For the videographer

on the go, Mini Cool-Luxes are a good combination of price and portability.

If, however, you spent your entire video budget purchasing that new DV camcorder, consider a trip to the hardware store. Now that you understand the different types of bulbs and the illumination they produce, you'll look at the "shop accessories aisle" in a whole new, uh ... light.

## Tip 8: How to master three-point lighting

Now that you have your lights, how are you going to arrange them? The classic approach to interview lighting uses three points of illumination: main, fill, and back. It's endured all these years for good reason: it's easy to set up, flattering for subjects, and appropriate in a wide variety of situations, including training videos, interviews, cooking demonstrations, and more.

Before throwing on the switch, however, you'll need a few basic accessories to complete your setup:

*Light stands.*  Get your hands on two 7-foot stands for the key and fill lights, and a shorter backlight stand. Light stands usually run between $50 and $150 U.S. each, and for most folks they are a once-in-a-lifetime purchase.

*Reflectors.*  Collapsible light discs are nice, but pricey. If you have them, bring them along. You can also use homemade foam core panels. Better yet, paint one side black and you have a tool to block light as well as reflect it.

*Clamps, clothes pins, and gaffer's tape.*  Sure, it would be great if reflectors, cords, drapes, and even loose clothing magically stayed exactly where you wanted them to, but they don't. Have a good supply of these items in your bag of tricks.

*Extension cord and adapters.*  You want to shoot in this corner, and the closest available outlet is in the other. Include

at least one extension cord and a couple of three-to-two prong electrical outlet adapters.

*Lighting gels.* Depending on the type of lights you're using, you might want to bring a few amber and blue gels that you can use to warm and cool the final lighting for the scene. Diffusion gels also come in handy to add softness to the light.

*Face powder, Kleenex, and comb.* If you're going to subject people to interrogation, uhh... I mean to shooting in front of hot lights, at least help them look good doing so. A little face powder really helps eliminate the shine on noses, foreheads, and receding hairlines.

So how do you take this mish-mash of bulbs, stands, clamps, and cords and arrange them to create beautiful lighting for your scene? Easy.

Take your brightest light, which is often referred to as the key or main light, and place it to the right of the camcorder, about three feet away, pointing toward the subject. (See Figure 3-6.)

Place your weakest light behind the model. You can position this light low angling upward toward the subject's head, or you can attach the light to the ceiling behind the model pointing downward toward the back of the head. This is called the *back light*, and its role is to create separation between the subject's head and the background.

Put your model in position and turn on the key and back lights. Examine the scene in your LCD monitor and note the shadow area on the model's face. Now place your medium-intensity light on the shadow side of the subject, directed at the dark area of the face. This is called the *fill light*.

Review your lighting again in the LCD monitor. If you need to, adjust the fill light or substitute a reflector for the light to get

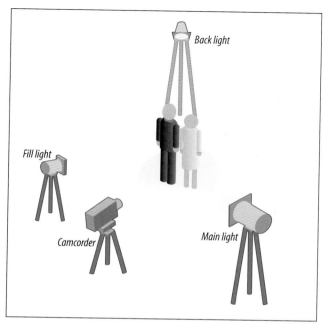

**Figure 3-6.** Three-point lighting combines main, fill, and backlights for a flattering rendering of the subject.

the look you want (see Figure 3-7). If the key light is too harsh, diffuse it by bouncing the light off a reflector on to the model.

Remember the rule of thumb for portrait lighting: The bigger the light source and the closer it is to the subject, the softer its illumination. By bouncing the light off a large reflector, you've essentially doubled or tripled *the size* of your source (not its intensity, though). The closer you move the reflector to the model's face, the softer the light will be. This is very flattering because it softens lines in the face and gives the complexion an overall smoother appearance.

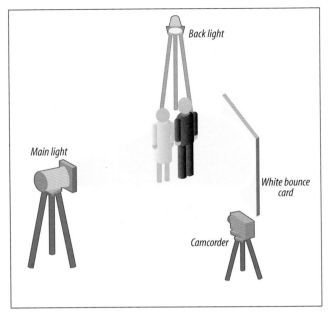

Figure 3-7. You can substitute a fill card or collapsible disc reflector for the fill light. The lighting is less even with this setup, but many filmmakers like the more pronounced shadow area resulting from this configuration.

Once you're satisfied with the position of the lights, note the color temperature of the scene as it appears on your LCD monitor. Is the light too "cool," rendering your model with bluish skin tones? (Remember, the cadaver look isn't "in" this year.) If so, you should add amber gels to one or more lights until you get the hue you want.

Commercial reflectors, such as the collapsible discs, often have a gold side in addition to the standard white or silver. By bouncing the key or fill light off the gold reflector, you can warm up the quality of the light, creating healthier skin tones.

Finally, before you start rolling the tape, take one last look at your subject. Is his hair combed? Do you see any shiny spots

on his forehead or nose? Is his clothing hanging properly? Make the final adjustments, then start taping.

If you're using photofloods or quartz lighting, you'll need to take a break after 15 minutes or so of shooting. Otherwise the heat will begin to take its toll on your model. Use this opportunity to review some of the footage to make sure it's looking the way you want. If you have to make a change, it's better to start over now and get it the way you want than to discover the problem while helplessly viewing it the next day in the editing room.

---

**PRO TIP**

People who wear glasses cause extra challenges when arranging the lights. You'll probably have to raise the key light higher than you want to eliminate light reflections in the lenses. If that doesn't work, move it a bit more to the side of the subject. Have the model keep her chin slightly lowered. Not only will this help with the reflections, it will also give the appearance of widening the subject's eyes for a more flattering look.

---

## Tip 9: How to survive special events

You've seen it happen before: a friend of yours is getting married and would like "just a little video of the ceremony and reception." Suddenly all eyes are on you. "You have a camcorder, don't you?" You nervously say yes. That was the easy part. But now, how do you survive this special event and deliver good video once it's over? Here are some survival techniques. The following tips also apply to graduations (which are weddings without the reception), birthday parties (weddings without the ceremony), and 50th-anniversary celebrations (weddings without the honeymoon).

Preparation begins long before the event unfolds. Here's how to get organized prior to the wedding and shoot well once the action starts.

*Find out what's happening at the event and when.* Organized weddings will have an itinerary or a shot list. Request a copy. This will help you stay ahead of the action during the event. You want to be in position and let the action come to you. Remember the basic shooting sequence outlined in Tip 1: How to shoot action video like a pro: Let the couple enter the frame, do a short pan, then let them exit the frame.

*Attend the rehearsal.* Bring your itinerary with you and make notes during the rehearsal. Don't be afraid to ask questions like "Is it OK if I stand here during the exchange of vows?" If the photographer is there, introduce yourself. The two of you can work out a game plan so you're not in each other's way during the actual event.

*Find an assistant.* True, you're not shooting *Four Weddings and a Funeral*, but even for small projects, an assistant is invaluable. This person can help you stay ahead of the itinerary, gather groups together, hold the microphone, and dash off to the car for that missing adapter you left in the trunk. And when the wedding is over, be sure to send a thank-you note with a thoughtful gift as a token of your appreciation.

*Prepare your equipment.* Since weddings get hectic, make sure you have extra videotape and batteries in your pockets. It's a good idea to format your tape first as described in Chapter 2 so there's no chance of breaking the time-code during the heat of the action. Bring a tripod for the ceremony and a monopod for afterward. You should have a portable video light with you, but pray that you don't need to use it. An external microphone is critical for decent audio during the reception. A wireless mic on the

groom during the ceremony should be good enough to capture the exchange of vows.

*Dress appropriately.* Yes, a tie-dye T-shirt does express your free and independent spirit. But a coat and tie or a dress says you mean business. These social events include people from all walks of life. First get their respect, then get the shot.

*Don't be a nuisance.* Resist the urge to direct, herd, and nag. Don't ever cut in front of the action when changing positions. Stay out of the still photographer's way. Smile a lot, but don't say much. Quietly go about your work so people forget about you. Then you'll get the great footage. (See Figure 3-8.)

**Figure 3-8.** At special events, the best footage is recorded when the subjects aren't aware of the camcorder. For this sequence the cameraman stood on a chair to get an engaging angle of the bride dancing with her father.

*Capture people talking to each other, not to you.* Try to record moments that are actually happening, not ones you create. If you want to interview guests, have your assistant

stand a little to your side and lead the discussion. That way interviewees won't be looking directly in the camera talking to you.

*Use good camera technique.* Hold your shots steady, don't zoom while the tape is rolling, and pan slowly. If you have to change positions, stop the tape, relocate, then start rolling again. Adhere to the five C's of good camera work: camera angles, continuity, cutting, close-ups, and composition.

*Edit your work.* For the love of Pete, don't just dump the entire day's footage on to VHS or DVD and hand it over to the couple. You don't need anything fancy here—just a few titles and simple cuts between scenes. Tell the story of the day as simply as possible.

*Try to deliver the movie soon after the event is over.* Delight the couple by having a DVD waiting for them when they return from their honeymoon. If you shoot clean footage and keep your editing simple, you shouldn't need too much time in post-production.

# In the Editing Room

## Tip 10: Export your digital video to QuickTime for web serving

One of the wonderful things about digital video is that it's digital. Once captured, you can do just about anything with it, including sharing via your personal web site. (See Figure 3-9.)

All you need is QuickTime Pro, which you can download from Apple (*http://www.apple.com/quicktime/download/*) for $29.99 U.S. The Mac and Windows versions work equally well. You'll find a wealth of other tools hidden away in QuickTime Pro that will help you present your work in new ways to others.

Figure 3-9. You can export your DV clips to QuickTime in many video editors. Here's the Export dialog box in Ulead's VideoStudio 7 that enables you to choose QuickTime.

Many Windows users don't realize that they have the same authoring tools available to them in QuickTime Pro that Mac users enjoy. But it's true! This tip will give you a taste of QuickTime's power and versatility.

Once you've downloaded QuickTime Pro, follow these basic steps to serve your video clips on the Web:

1. *Edit your movie down to a 2–3 minute piece.* Think of video on the Web as an entirely different medium—a more compact, to-the-point presentation.

2. *Create your opening and closing titles.* Again, simple is better here. White letters on a black background are just fine. Make the type relatively large: your movie frame is only going to be 320 x 240 pixels, so you want viewers to be able to read the type easily. Also, it's best to center your titles for these productions.

3. *Find "Export to QuickTime" in your video editor.* How you do this varies from movie editor to movie editor. For

example, in VideoStudio 7 for Windows, go to the Share tab → Create Video File → Custom and select QuickTime from the format pop-up box. In iMovie for Macintosh, select Export → To QuickTime → Expert Settings. Some very basic applications such as Windows Movie Maker only allow you to export to a single format, such as *.wmv*. If that's the case, it's time to consider adding another video editor to your bag of tricks.

4. *Enter the proper settings and export.* See Table 3-1 for the optimal settings for web serving.

**Table 3-1: QuickTime settings**

| | |
|---|---|
| Frame Size | 320 x 240 |
| Video Compressor | Sorenson Video |
| Frame Rate | 10 or 15 fps |
| Audio Compressor | QDesign Music for mixed audio; Qualcomm PureVoice for dialog only |
| Audio Rate | 22.050 kHz |
| Internet Fast Start | Yes |

Once you've exported your movie, upload it to your web server. If you have a .Mac account, simply place it in your *Movies* folder and use the HomePage tool to publish the movie on the Web. If you have a personal web site with access to the server, upload the movie and create a web page to display it. Here is sample code to make sure your movie displays and plays properly on a variety of web browsers:

```
<object classid="clsid:02BF25D5-8C17-4B23-BC80-
D3488ABDDC6B" width="320" height="240"
codebase="http://www.apple.com/qtactivex/qtplugin.cab">
<param name="SRC" value="your_movie.mov">
<param name="AUTOPLAY" value="true">
<param name="CONTROLLER" value="true">
<embed src="poppies_in_motion.mov" width="320"
height="240" autoplay="true" controller="true"
pluginspage="http://www.apple.com/quicktime/download/">
</embed>
</object>
```

Enter the name of your movie file for the value on line 4. You can control the autoplay functionality by entering true or

false on lines 5 and 8. You can also specify whether the controller appears on the web page—enter true or false on lines 6 and 8.

Upload the web page to your server, and now you and your fans can enjoy an online web movie of your making (see Figure 3-10).

**Figure 3-10.** QuickTime movies play equally well on Windows (top image) and Macintosh platforms (bottom image).

If you've managed to keep your file reasonably svelte (2 MB or less), you can also attach your movie to an email and share it that way. Before you send it along however, dash off a "warning" email to the potential recipient and wait for a confirmation. That way your attachment will be eagerly anticipated instead of silently disdained.

## Tip 11: Burn DVDs for archive as well as sharing

The ability to create professional-looking DVDs that contain a menu of your movies is the icing on the cake for digital filmmakers. Yes, you could always transfer your films to VHS and distribute them that way, but the process of moving from digital (DV) to analog (VHS) involves loss of quality. Not to mention that VHS tapes lack the "wow!" factor that DVDs elicit with their animated menus and easy search capabilities.

If you're interested in creating production-quality DVDs, you might want to look at video editing packages that have integrated DVD authoring. The two bundles mentioned often in this guide—Apple's iMovie 3, which is a part of the iLife bundle that includes iDVD 2 (for Mac), and Ulead's VideoMaker 7, which has integrated DVD authoring or works with Ulead's DVD MovieFactory 2 (Windows)—enable you to flow from editing your work directly to burning it on DVD.

But there's another equally compelling argument for adding a DVD burner to your video workstation: archiving your projects.

When you're working with any video editing application, from Microsoft's Movie Maker to Adobe's Premiere, you'll be constantly adding project files to your hard drive that include items such as animated titles, media clips, soundtracks, and still images. If someday you wanted to return to a project to remix the music or re-edit some video, you'll want your project and its files exactly the way you left them so you can pick right up with your work. Needless to say, these projects begin to add up to lots of hard-disk space.

One solution to free up your hard drive and keep your movie projects intact is to archive them on DVDs. Single-sided DVDs can accommodate up to 4.7 GB of data, and double-sided DVDs hold much more.

If your movie project is less than 4.7 GB, you can simply burn it intact to a blank DVD. Larger projects have to be divided into folders that are distributed to multiple discs. You should consider burning two sets of discs for each movie project—one to keep in your editing studio and another for offsite. As with the original video itself, keep logs of your projects so you can easily retrieve the correct discs if you want to go back and remaster a movie.

DVDs for replay in set-top players are a great way to distribute your videos, but using this technology for archiving also ensures that you'll always be able to go back and pick up your work right where you left off.

For more information about DVD authoring, compatibility, and equipment, take a look at the site *http://www.dvdrhelp.com/*.

## Tip 12: Labels, jewel cases, and finishing touches

You don't want your DVD—the one that contains hours of your sweat and creativity—to end up in the middle of an anonymous heap of forgotten discs in the corner of your best friend's desk. To ensure this doesn't happen, create an attractive label and jewel-case insert to distinguish it from the others.

In the professional world, marketing a movie can cost as much as actually making it. You are not faced with competing with hundreds on titles on the shelves of Blockbuster Video, but you do want your work to be easily identifiable and attractively packaged.

Tools such as CD Stomper Pro (*http://www.cdstomper.com/*) enable you to design custom inserts and labels that add the finishing touch to your project.

One note, though: Try to get DVD labels that are as thin as possible. Sometimes cheaper "fat" labels don't sit well in set-top DVD players and computers. Get a few samples and test them. Once you find a system you like, you can ensure that your DVD never becomes lost in a sea of nameless discs on someone's desk.

## Time to Shoot

This book is designed as a pocket guide for a reason. Put it in your camera bag! Yes, it's fun to read about shooting techniques in the comfort of your home, but you're not going to memorize every word, technique, and chart.

When you're on location and waiting for the event to begin, pull out this book, read a few pages that apply to the work you're about to do, and incorporate these tips into your style of filmmaking.

You're about to capture new worlds through the lens of your camcorder. Get out there and make it happen.

# Appendix
## Quick Reference Tables

The following tables will serve as a handy reference as you capture and transfer data with your digital camcorder. Most of the settings described in this section are to be used as starting points. For best results, test with your particular equipment.

Table A-1. Color temperature chart in Kelvin.

| Degrees Kelvin | Type of light source |
| --- | --- |
| 1700–1800K | Match flame |
| 1800–2200K | Dawn, dusk, candle flame |
| 2400–2600K | 40W incandescent bulb |
| 2800–3000K | 100W incandescent bulb |
| 3200–3400K | 500W photoflood bulb, Quartz bulbs |
| 4200K | Sun at 20 degree altitude, cool white fluorescent bulb |
| 5400K | Sun at direct noon |
| 5500K | Photographic daylight |
| 5500–6000K | Hazy sun, photo electronic flash, HMI lamp, neons |
| 6500–7000K | Bright sun, daylight fluorescent bulb |
| 8000–9000K | Open shade outdoors, overcast sky |
| 9000–10000K | North light, skylight window |

**Table A-2.** Color correction gels to convert tungsten light to daylight (or HMI light).

| Conversion gel | Converts K | To K |
|---|---|---|
| Full blue (CTB) | 3200 | 5600 |
| 3/4 blue (3/4 CTB) | 3200 | 4700 |
| 1/2 blue (1/2 CTB) | 3200 | 4300 |
| 1/3 blue (1/3 CTB) | 3200 | 3800 |
| 1/4 blue (1/4 CTB) | 3200 | 3600 |
| 1/8 blue (1/8 CTB) | 3200 | 3400 |

Note: Color temperatures are general guidelines. Your results may vary depending on light source and gel density.

**Table A-3.** Color correction gels to convert daylight to tungsten light.

| Conversion gel | Converts K | To K |
|---|---|---|
| Full orange (CTO) | 5500 | 3200 |
| 3/4 orange (3/4 CTO) | 5500 | 3200 |
| 1/2 orange (1/2 CTO) | 5500 | 3800 |
| 1/4 orange (1/4 CTO) | 5500 | 4600 |
| 1/8 orange (1/8 CTO) | 5500 | 4900 |

Note: Color temperatures are general guidelines. Your results may vary depending on light source and gel density.

**Table A-4.** Color correction gels for fluorescents.

| Conversion gel (over light source) | Converts | To |
|---|---|---|
| Plus green | HMI and tungsten | Fluorescent |
| Minus green | Fluorescent | Photo daylight (5500K) |

Note: Color temperatures are general guidelines. Your results may vary depending on light source and gel density.

**Table A-5. Lux ratings in common lighting situations.**

| Lighting condition | Lux rating | Comments |
|---|---|---|
| Directly illuminated by bright sunlight | 100,000 | |
| Full daylight | 10,000 | 5400K |
| Bright overcast day | 1,000 | |
| Open shade on lightly cloudy day | 500–1,000 | 8000–9000K |
| Brightly lit natural light interior | 500 | Multiple windows open with no added artificial light |
| Commercial artificial lighting indoors | 150 | Typical shopping mall with no added daylight |
| Dark overcast day | 100 | High quality threshold for most camcorders in daylight mode. |
| Typical restaurant, coffee shop artificial lighting | 100 | Bright enough to easily read menu |
| Room illuminated by single ceiling light bulb | 50 | Lightly painted walls, single 100W light bulb, 2800–3000K overhead |
| Early twilight | 10 | 800–2200K |
| Late twilight | 1 | |
| Full moon | 0.1 | |
| Starlight | 0.001 | |

**Table A-6. Video minutes to hard-disk space used.**

| Amount of video transferred | Hard-disk space used |
|---|---|
| 1 minute | 216 megabytes |
| 5 minutes | 1,080 megabytes or 1.1 gigabyte |
| 10 minutes | 2.2 gigabytes |
| 15 minutes | 3.2 gigabytes |
| 20 minutes | 4.3 gigabytes |
| 25 minutes | 5.4 gigabytes |
| 30 minutes | 6.5 gigabytes |
| 35 minutes | 7.6 gigabytes |
| 40 minutes | 8.6 gigabytes |
| 45 minutes | 9.7 gigabytes |
| 50 minutes | 10.8 gigabytes |
| 55 minutes | 11.9 gigabytes |
| 60 minutes | 13 gigabytes |
| 90 minutes | 30.6 gigabytes |
| 120 minutes | 26 gigabytes |

**Table A-7. Video cables and their connectors.**

### Component video

YUV connection (Y is luminance, U is red minus Y, and V is blue minus Y) between devices using RCA connectors. High quality because signals are separated resulting in less interference. Recommended for video transfer, DVD players, and computer monitors.

### Composite video

Single cable transfers both luminance and chrominance information between devices using an RCA connector. Because of resulting image degradation, best for monitoring purposes only, or for transfer when other connectors aren't available.

### FireWire 400 (IEEE 1394, i.LINK)

Transfers video and audio information between devices up to 400 Mbps using the IEEE 1394 communications protocol. Commonly used to transfer data between digital camcorder and the computer using a 4-pin connector for the camcorder and 6-pin connector to the computer. Extremely fast, high-quality transfer—up to 50 MB per second.

### FireWire 800 (IEEE 1394b)

Transfers video and audio information between devices up to 800 Mbps using the IEEE 1394b communications protocol. Twice as fast as original FireWire and uses a 9-pin connector. Not common on digital camcorders yet, but gaining popularity for external hard drives. Backwards compatible to FireWire 400 with adapter.

### Radio Frequency (RF) (also known as coaxial)

Transfers analog signal along copper wire by combining video and audio signals into single radio frequency. Since signal is transferred as radio waves along wire, it is vulnerable to interference from other electrical devices. Use only when no other connector is available.

### S-Video

Two-wire connection that separates the Y (luminance) and C (chrominance) signals and uses a 4-pin connector (other 2 wires are ground). Because the Y and C signals run on separate wires, S-Video is higher quality than Composite Video. 4-pin connecter is more fragile than composite's RCA jack.

### USB 1.1

Relatively slow transfer rate (12 Mbps) compared to FireWire. Used primarily for still-image uploading on DV cams with high-quality still-photo capability. Not recommended for video transfer because of slow rate, but useful for other data such as still photos and compressed audio.

### USB 2.0

Much improved transfer rate compared to USB 1.1 (480 Mbps compared to 12 Mbps). Uses same style connector. Capable of similar transfer rate as FireWire 400. Not common on digital camcorders at this time, but widely used for hard drives and photo scanners.

**Table A-8. DV tape log sheet template.**

| Start Time | Date | Project | Description |
|---|---|---|---|
| 00:00:10:00 | May 2, 2003 | KK-J10 | Long shot of convention center. |
| 00:01:24:00 | May 2, 2003 | KK-J10 | People entering and exiting the building. |
| 00:03:41:00 | May 2, 2003 | KK-J10 | Close up of little boy eating a cookie. |

**Table A-9. Types of microphones and their characteristics.**

#### Condenser microphone

Contains built-in amplifier, increasing microphone's sensitivity. Sometimes known as capacitor microphone. Built-in amplifier requires some sort of power, either batteries or through the connection to the camcorder. More expensive than dynamic mics. Records sound "as it really is." Less rugged than dynamic mics.

#### Dynamic microphone

Rugged, simple technology that responds to changes in air pressure caused by sound waves. Uses "moving-coil" technology. Inexpensive and not as sensitive to quiet sounds as other types of microphones. High-quality versions are good for traveling.

#### Lavalier microphone

Small, electric microphone that's usually attached to the collar of an interviewee. Need to be as close to source as possible for best sound recording. Clip on collar if possible, not down too low on shirt.

#### Wireless microphone

Attached to transmitter (or transmitter included inside) using radio frequency instead of cables for connection. Typically transmit on one frequency per mic. But "true diversity" models use two antennae for better performance.

**Table A-10. Types of microphone pickup patterns.**

### Bidirectional pattern

Records in a "figure 8" pattern and was once popular for two-person conversations and duets. Less common today when the preferred method is to mic each person individually.

### Cardioid pattern

Often referred to as "semi-unidirectional" microphones because they dampen sounds from all sides except the direction they're pointed. Will still pick up some general ambient sound, but not as much as "omnidirectional" mics that record sound in all directions.

### Omnidirectional pattern

Picks up sound in all directions. Good for recording ambient sound or large groups of people.

### Unidirectional pattern

Picks up only the sound in the direction it's pointed. Sometimes referred to as hypercardioid or "shotgun" mic. Good for recording individual voices in noisy locations. Can also be used to pick up sound from a distance.

# Index